# How to
# PHOTOGRAPH
# WOMEN

**HPBooks**
a division of
PRICE STERN SLOAN
Los Angeles

**Notice:** This material was first published in England in the magazine You and Your Camera, produced by Eaglemoss Publications Limited. It has been adapted and re-edited for North America by HPBooks. The information contained in this book is true and complete to the best of our knowledge. All recommendations are made without any guarantees on the part of Eaglemoss Publications Limited or HPBooks. The publishers disclaim all liability in connection with the use of this information.

Published by HPBooks, A division of Price Stern Sloan, Inc.
360 North La Cienega Boulevard
Los Angeles, California 90048
ISBN: 0-89586-117-8 Library of Congress Catalog No. 81-82135
© 1981 Price Stern Sloan, Inc. Printed in U.S.A.

12 11 10 9 8 7

# How to _____
# PHOTOGRAPH
# WOMEN _____

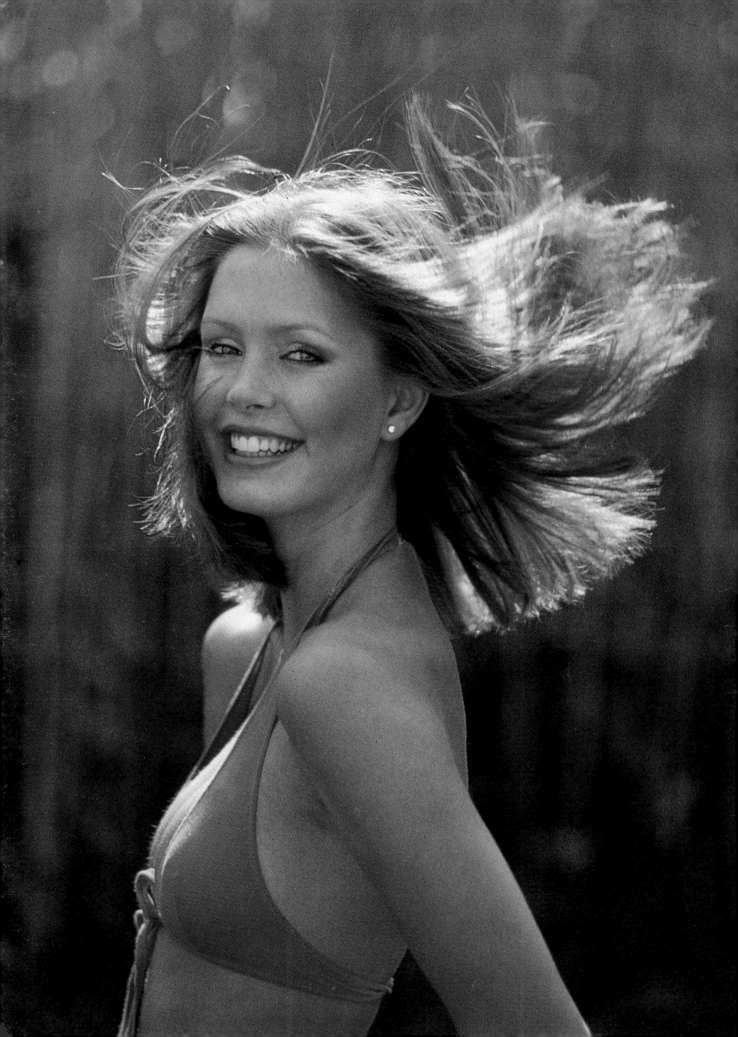

# Contents

# Photographing Young Women

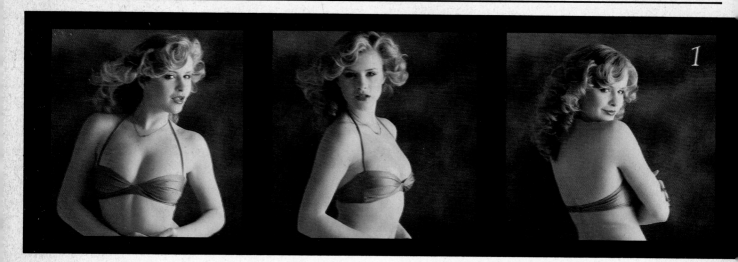

One popular subject for photographers is young women. They project an innocence that the photographer can use in many ways to create universally acceptable images.

Every major city has agencies with files containing pictures and information about models for every occasion. The selection of the right model for advertising has become a demanding job. The young lady you see in an advertisement sipping a beverage or eating chocolates may have been one of many who were interviewed by the advertising agency or photographer.

If you simply want to take pictures of an attractive young lady, this complicated selection process is unnecessary, time consuming and expensive. You have to please yourself rather than the general public. Nevertheless, the right model may assure success for the beginner as well as the experienced photographer. Planning can save disappointment later.

If you want to learn how to photograph the female form, consider joining a camera club. Many clubs periodically organize studio or location photo sessions for members. For your first attempt at this type of photography, you may want to use the studio and the model they choose. Or, you may prefer to choose your own model and location.

## CHOOSING THE MODEL

First, ask someone *you* find attractive to model for you. This may seem obvious, but it is easy to be misled by helpful friends who "know someone who knows someone who would make a wonderful model." It is not necessary to change your tastes to make a photograph. The media concept of an attractive woman may not be what you consider ideal.

Choose someone you know well so you *and* the model can be relaxed for the first few sessions. Being comfortable in front of or behind the camera comes with experience. Eventually, you may want to photograph strangers. Practicing with a friend helps you toward that goal.

An inexperienced model probably will not have a portfolio of photographs of herself. In exchange for her modeling services, offer her enlargements of the best results of the photo sessions. As a result, you both gain experience, and also have tangible results from the time spent.

**Portfolios**—If your subject wants to become a professional model, or you wish to sell your photography, you will both

need good samples to show to prospective customers. A portfolio is an excellent way to show off your photography. It consists of a cross-section of what you feel is your best photographic work, mounted in a way that complements the images. It should contain enough samples to demonstrate your abilities, and to interest the viewer. If he wants to see more, you can choose additional photos based specifically on his request.

## CLOTHES AND MAKEUP

The model's wardrobe should be based on her personal preference and the mood you want in the pictures. Don't ask her to dress in a way that will make her feel un-

1) For the studio shots above, Martin Riedl used a simple lighting setup of one diffused side-light on the camera's right and a reflector on the left.

2) Outdoors, choose locations that contribute to the photograph's impact. Framing the subject in a window adds that extra touch to this model's pose.

◄ One way to find a model for glamour photography is to attend a camera club session in a studio or on location.

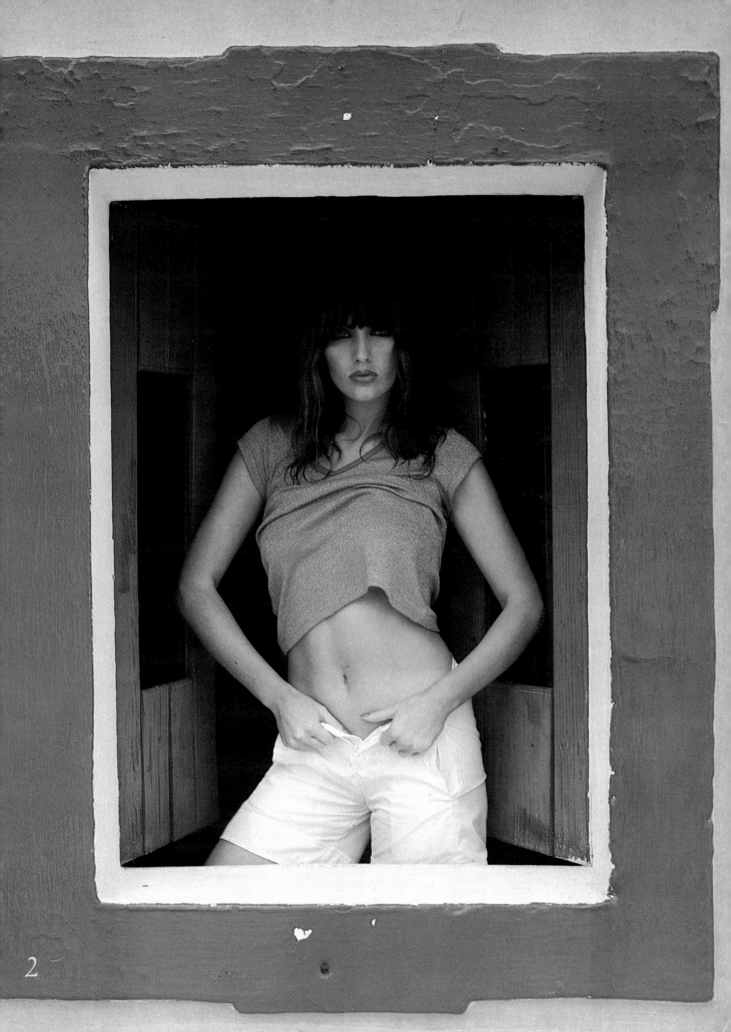

2

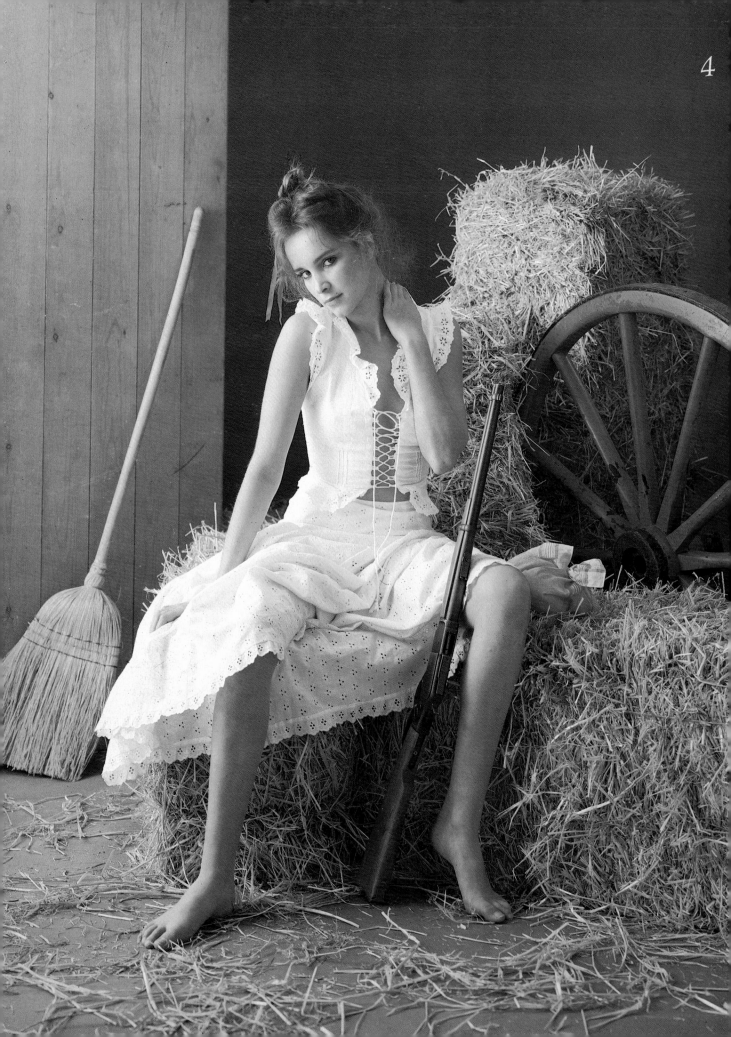

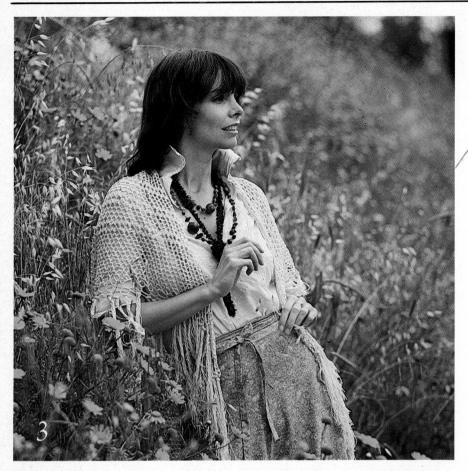

3

comfortable. She shouldn't be overly self-conscious. She should be relaxed and comfortable.

Ask her to bring a selection of various colored clothes because the background and lighting often influence what she should wear for the photo session. Props, such as scarves, jewelry or a hat can sometimes add an extra touch that completes the picture.

**Makeup**—Although discussed in detail beginning on page 44, here are some general hints about the use and misuse of makeup.

Makeup can contribute to the success of a picture but, if used improperly, it can be detrimental. Too little rather than too much is the best general rule. Slightly tinted powder covers unwanted shine on the skin, mascara adds definition to eyelashes, and lipstick adds shape to the mouth.

Don't shade the face with blusher unless it is expertly applied. Use makeup to mask blemishes. When a lot of skin will be visible, it usually looks best if it is brown rather than stark white. Tinted suntanning oil will make skin look darker.

## WHERE TO SHOOT

The setting may be indoors or outdoors, under natural or artificial light, in a studio or on location. Make the atmosphere as relaxed as possible. If your model is not a professional, avoid artificial lighting and complicated studio sets. Outdoor settings give you both less to worry about.

Whatever situation you choose, make sure you are organized. Give the impression that you know what you are doing, even if you are still learning. Have the camera loaded with film, lighting equipment arranged, and props and background in position.

If it is your first session, consider practicing beforehand with someone other than the actual model. Try different lighting setups, poses and camera angles. Then you will be relaxed and in charge of the situation when she arrives. When shooting outdoors, know where the sun will be during the session. If necessary, you should also have flash for fill light or a reflector to lighten the shadows.

Do you have a place for your model to change and put on her makeup? Would some props be useful—a hammock maybe, or a beach chair? If the session is going to be long, how about something to drink? The more organized *you* are, the more you will *both* enjoy the experience.

3) For an inexperienced model, an outdoor setting is less intimidating than a studio. If possible, choose a hazy day for softer lighting effects. Photo by Michael Busselle.

4) You can tell a story with a careful choice of props, clothes and location. The photographer used a reflector and electronic flash through a large diffuser for a natural lighting effect in this photograph.

5) You can create a feeling of humor by using incongruous settings and props.

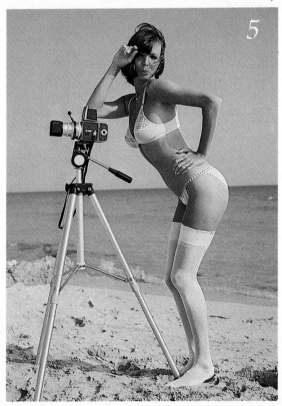

5

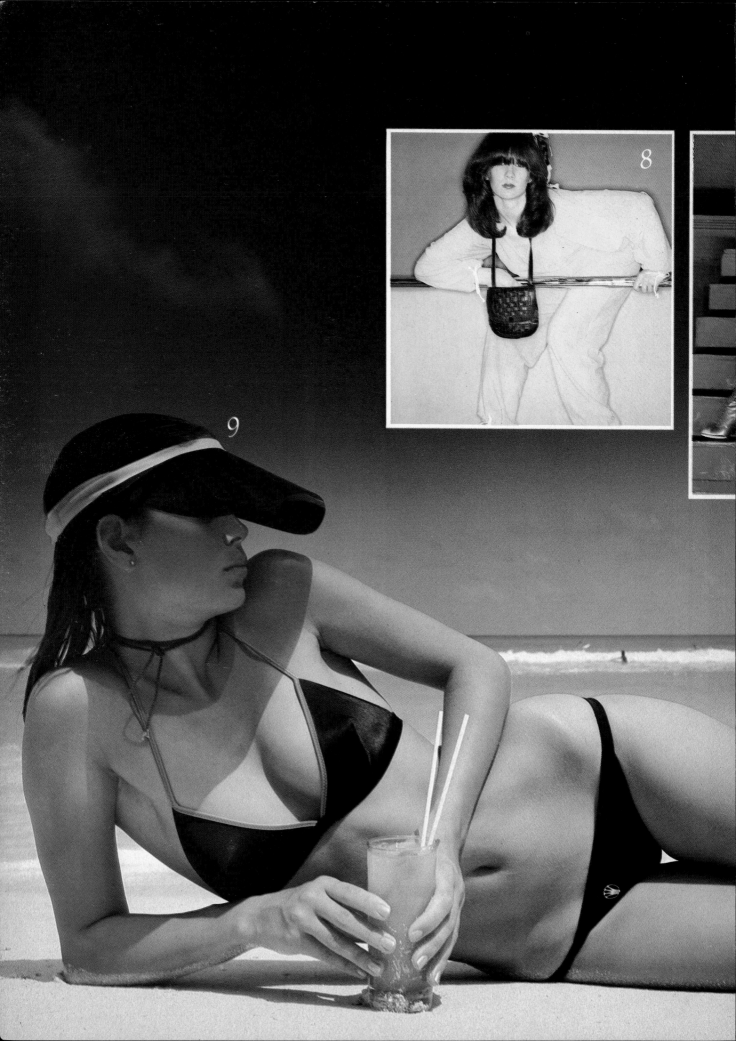

8

9

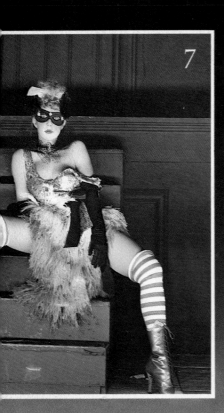

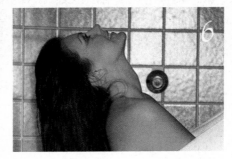

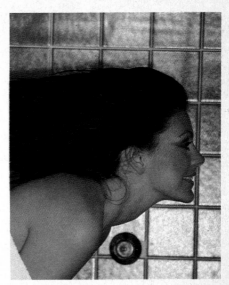

6) This photograph was planned for use on its side, as shown at right. The profile and streaming hair look like a ship's figurehead. Tino Tedaldi used flash close and exposed film during peak action as the model flung her head back.

7) James Wedge used an SLR with 85mm lens and flash directed at the floor for the low key lighting effect of this picture. He used Ilford FP4 film and hand-colored the b&w print.

8) This model is standing in front of two sheets of background paper. The joint is hidden by the pole in her hands. Howard Kingsnorth lit the shot with a ring flash around the 150mm lens of his Hasselblad.

9) A graduated filter, normally used to reduce contrast between sky and subject, dramatically darkens the sky here. A wide-angle lens isolates the model even more by exaggerating the distance to the horizon.

## EQUIPMENT

Be familiar with every piece of photographic equipment you are using. *Never* try something new on your first session with a model. It creates a bad impression if you don't seem to know your equipment, and it may diminish your confidence if you make mistakes that ruin the photographs.

A tripod is useful in photography of women because it allows you to position the camera and walk away from it while you fine-tune the lighting, make exposure readings and other adjustments. For daylight work, have a large reflector and stand available.

A medium-telephoto lens, such as an 85mm, 105mm or 135mm, is an asset if you have a 35mm SLR accepting interchangeable lenses. It enables you to work

farther away from your model than with a standard 50mm lens. Thus, you don't have to get too close and crowd her. A longer lens can also help subdue background details when you use large apertures, particularly when you are shooting close-up portraits.

## DIRECTING A MODEL

The best rule about directing a model is—don't, unless you have to. Contrived poses may look phony. The secret is to establish a situation by your choice of conversation, background, props and clothes, in which the model can forget the camera and be herself. Picture-taking then becomes almost incidental.

If you still have to direct her after the first few shots, something may be wrong. It might be best to take a break and start again.

To properly direct a model, you should first establish rapport with her. Tell her what you would like in the photos. Ask her opinion and get some feedback. Then the direction and poses will come naturally during the session. This relationship is based on her confidence in you as a photographer and your efficiency in organizing the session. It also comes from the knowledge that you find her interesting and attractive. With rapport and understanding, you'll both enjoy the session.

This is true of professional models, too. It is easy to take bad pictures of experienced models if you lose their confidence or they begin to feel insecure or unattractive. This is why many fashion photographers keep up constant communication with the model. They never lose that important link for an instant.

# Nude Photographs

When you first decide to photograph a nude female, the biggest problem is likely to be—who? There are two solutions to this, each with its own advantages and potential difficulties.

## PHOTOGRAPHING A FRIEND

The first and most obvious subject is a friend or family member. However, many people feel uncomfortable enough in front of a camera—even when the photo is only for a passport! Nudity—partial or total—increases inhibitions, however well the model may know you. If you want to use a model with no photographic experience, you must help her relax and enjoy the session.

The model must be sure the pictures are going to be good, and that you know what you are doing. The best way to gain her confidence is to start by shooting pictures of her clothed. If she likes the results, there is less likelihood she will be skeptical when you ask about nude modeling. Even a close friend may decline if she doubts your abilities or intentions.

## THE PROFESSIONAL MODEL

For your first session with a nude model, you may decide to find one with experience who has already overcome these inhibitions. As mentioned earlier, some camera clubs organize nude photography sessions for their members.

Some studios specialize in such facilities for photographers. They are usually arranged so several photographers can work with a model in one session. Although this is far from ideal, it reduces the cost per person. It may also provide you with an introduction to basic methods because you'll be able to learn other photographers' techniques at the same time. The experience and confidence you gain from such group sessions may be valuable later on.

You may want to photograph a professional model on an individual basis. This is more expensive, of course, but it means

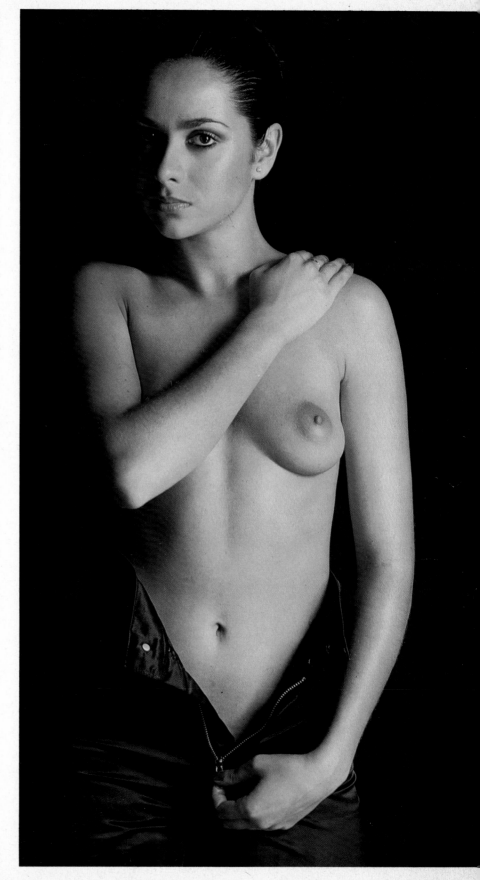

► In the controlled environment of a studio, you can concentrate on the model. Here, the photographer used one large light 45 degrees to the lens axis. This isolated the figure on a dark background.

▶ A beach is a natural setting for informal nude shots, offering interesting lighting conditions. The pale sand acts as a useful reflector. John Kelly used back lighting here.

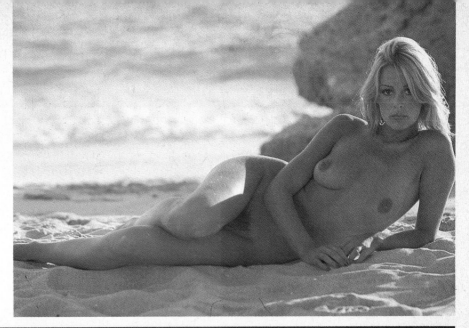

▼ Photographing at home gives you more time to plan your shots and control the results. This background was chosen to blend with skin tones. Photo by John Garrett.

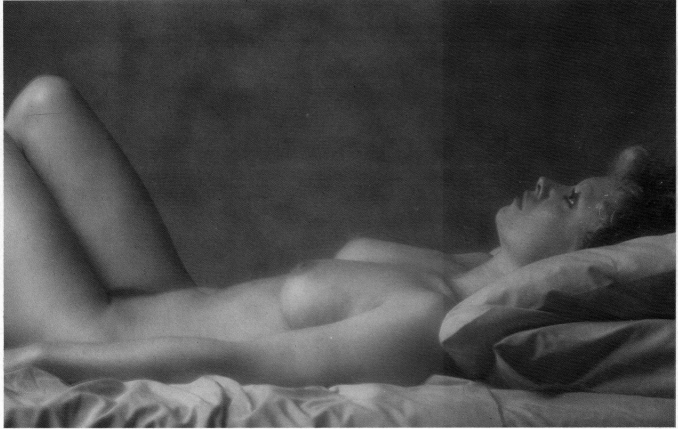

you have her complete attention and can completely control the session. A good, experienced model can indirectly teach you a lot about this type of work, suggesting pictures by posing in various ways, thus encouraging your own creative ideas.

Most major cities have model agencies that supply listings of prospective models. Not all professional models will pose in the nude. Specify what you want when you first approach the agency, and remember that nude modeling fees may be 50 to 100% higher than for conventional clothed modeling.

## DIRECTING THE MODEL

Know what kind of pictures you want to take. You may like the soft romantic style of photographers like Sarah Moon and David Hamilton; the more stark and dramatic approach of Bill Brandt and Helmut Newton; or the abstract approach, with the body photographed as a "landscape."

Study nude photographs and figure out how they were taken before you start your own photo session. Show your model examples of the type of images you wish to produce. This will give her an oppor-

tunity to get into the mood of the session and understand how she can help you.

With this approach, you are not copying the work of established photographers—you are using their styles as a learning tool. It is better to have some basic idea—original or not—than simply hoping something works. Once shooting begins, and you become absorbed in the session, you will find that fresh ideas develop.

## BACKGROUND AND PROPS

Another element to consider is the background. This can be simple, such as a

▼ Give the model something to do while you photograph her. This gives the pictures an added appeal. Although this shot was posed, you might try letting the model move around while you watch through the viewfinder for the best composition. Photo by John Kelly.

▶ A picturesque setting makes the model's pose less crucial as she becomes only one element in a larger composition.

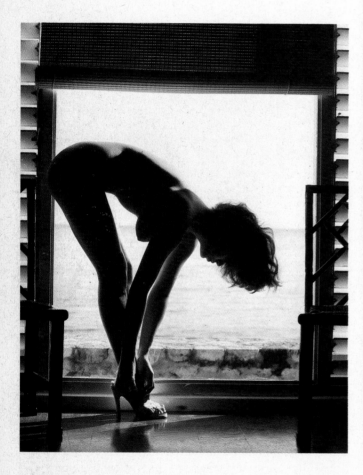

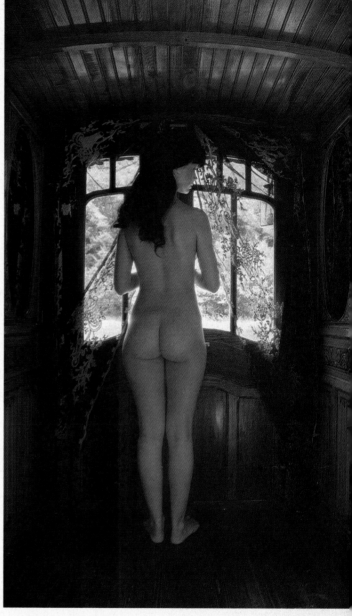

roll of seamless paper or a wall. Or, it could be more complex, like the interior of a room, a piece of furniture, or even an outdoor scene. The background should not clash with the mood you want.

For example, don't use a busy background such as trees when you want to produce an abstract nude picture with a simple graphic quality. It would also be inappropriate to position the model against a harshly lit brick wall.

Consider what props complement the mood. Background may not be enough. It can be difficult, especially for the inexperienced model, to relax without something to hold onto or react to—something that

also may help her position her body. A chair or a stool may be all you need.

Props can be much more complicated than this, of course. A photograph can be so elaborately propped that the model becomes only one element of the overall composition. Advertising and fashion photography in magazines demonstrate how effectively a simple piece of furniture, a basket of flowers or a telephone can help make an image work well.

## LIGHTING

Proper lighting is important. When working indoors, direct light through a large window is an adequate source. It

must be diffused to soften the hard edges of shadows cast on the subject or background. When photographing nudes, you want soft, even lighting. Window lighting is less easily controlled than studio lighting and offers fewer creative possibilities but is an adequate light source if used properly.
**Daylight**—You should have one or two 3x6' (1x2m) reflectors when using daylight indoors or out. Reflectors are available at your photo dealer, or you can make them out of white cardboard, polystyrene or wood painted white. Use them outside the image area to reflect light into shadows by propping them against a chair or a spare tripod.

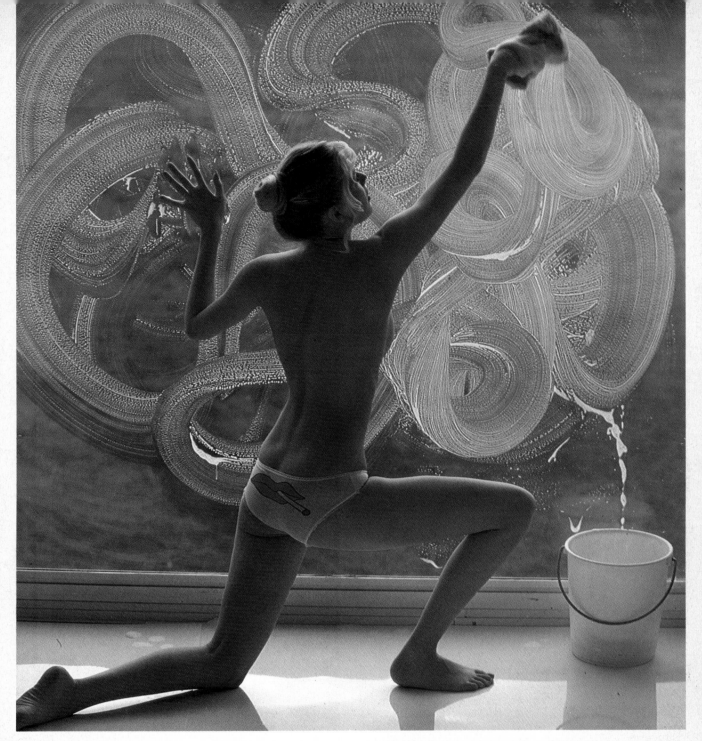

▲ Props can give a picture a storyline. Michael Boys supplemented available light with two white reflectors here. Note how the soapy window sets the model off from the background and adds a graphic element.

▶ Candid photographs of sunbathers can lead to relaxed poses. One basic problem is that you seldom get good photographs of people in direct, overhead sunlight. However, with the model lying on her back in this shot, the sunlight becomes acceptable front lighting.

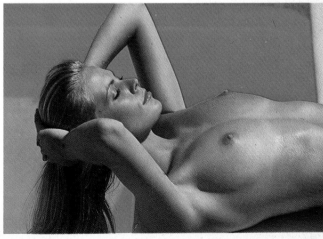

**Artificial Lighting**—Artificial lighting doesn't have to be elaborate. Two or three tungsten lamps with reflector housings on floor stands will provide many effects with a few simple accessories.

With studio lights, you can simulate the large, soft light source of a north-facing window. Cover a 3x6' (1x2m) wooden frame with tracing paper. Place this between the studio light and the model. Shine the light through it. It will diffuse the light for good detail, eliminating hot spots. And shadows will not be sharply defined—they will have have soft edges.

To regulate the softness, vary the distance between the screen and the light source—the farther apart they are, the softer the light becomes. Thus, when the screen is very close to the lamp, it will have only a slight softening effect. Don't get it so close that it burns or scorches due to heat from the tungsten lamp.

Another method of producing this effect is to a use a white wall or ceiling to *bounce* light from the studio lamps. A better way is to bounce the light from large reflectors. Spreading out and diffusing the light invariably offers more pleasing results than direct light because the effects are softer—unless you want a dramatic or theatrical effect with more defined shadows.

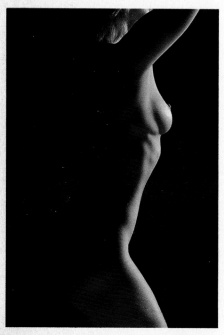

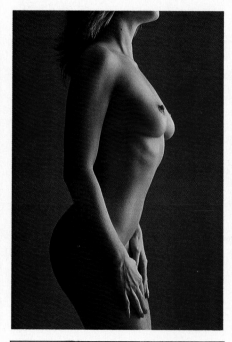

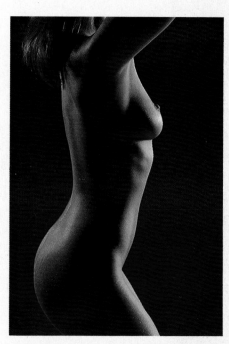

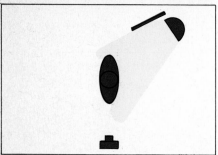

▲ To demonstrate the effects of different lighting setups, Michael Busselle first positioned a small directional light to one side of his model. This produced strong modeling and a stark effect, particularly because he posed the figure against a dark background that was carefully screened from any spill light from the source.

▲ He then diffused the light to effectively increase the size of the source. This created a gradual transition from light to dark areas for a softer, more romantic result. The effect of a diffuser varies with its distance from the light—the farther away it is from the light, the greater its effect.

▲ With another light on the opposite side and slightly farther away, more of the figure is lit. Here Busselle didn't use a diffuser. He screened the background from spill light to make the figure stand out. If you have trouble keeping areas dark, absorb stray light with black pieces of cardboard.

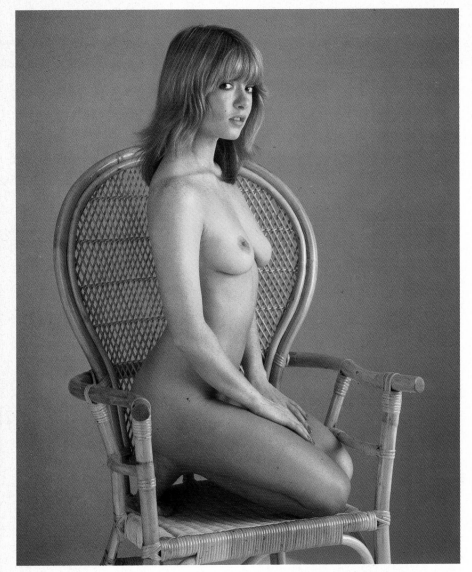

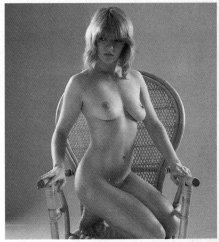

▲ Two diffused lights placed on either side of the model toward the back produced a rim-lit look. A reflector close to the camera fills in the front shadow area. Two screens in the back maintain a dark background. With back lighting, use a lens hood to prevent flare.

▲ Here, one diffused light is positioned closer to the camera, toward the front of the model. The strong modeling effect is lost in favor of more overall coverage. A reflector cast light on the shadow side. The overall effect is balanced, even tones. The background is lit.

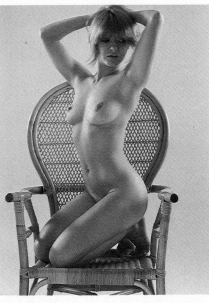

◀ In this variation of the above lighting setup, Busselle used the same reflector for a completely different effect. The screens were removed to make the background lighter. The rim-lighting shows up less clearly but the light background puts the figure into strong relief and gives a more dramatic effect.

# Using Daylight

After choosing a model, the next most important factor is a suitable location. A conventional studio with artificial lighting presents many possibilities, but you must be experienced and have the time to make adjustments to lighting and backgrounds. If you don't have a home studio, the cost of renting a studio may make you feel rushed, possibly causing mistakes.

Outdoor locations are less discouraging, but other problems exist, such as bad weather and lighting conditions, and the lack of privacy and comfort.

Use daylight indoors as a compromise. If you select a room with a large window, you will find a number of advantages: It is private and comfortable; you don't have to worry about the weather; and it is easier to use than a studio equipped with artificial lighting.

## CHOOSING THE ROOM

Adequate daylight from a large window, French windows or even a skylight is the first consideration. Bring in backgrounds, props, furniture and other items as they are needed.

Look for a room with an appealing characteristic such as an interesting shape or sloping ceilings. Along with suitable furnishings and decor, this type of environment can provide inspiration for you and your model. You may want to introduce additional props such as a plant or rug.

Always plan in advance. Before the session, check angles, lighting and other details while looking through the viewfinder. This will help you choose the correct lens and indicate what you may need to add or remove from the room.

## THE WINDOW

A large north-facing window or skylight not exposed to direct sunlight is ideal. Sunlight through a window *can* produce attractive lighting if you control the *lighting contrast.* This is defined as the amount of light in the lit area relative to the amount of light in shadow areas. High lighting contrast implies dark shadows. Low lighting contrast implies soft shadows.

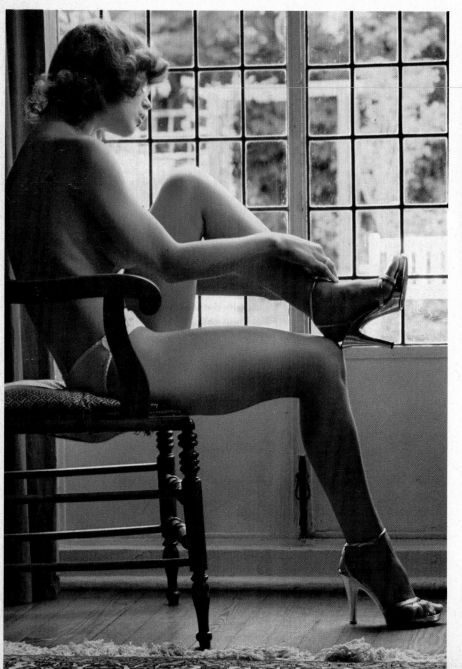

▲ A window provided dramatic, directional light for this photo by Raul Constancio.

◄ When shooting by daylight with the model against the window, base exposure on the light reflected from the model. Otherwise, the result will be a silhouette. Photo by John Garrett.

▶ A window can be used as a framing device. A prop, such as the telephone, gives the subject something to do with her hands. Photo by Michael Boys.

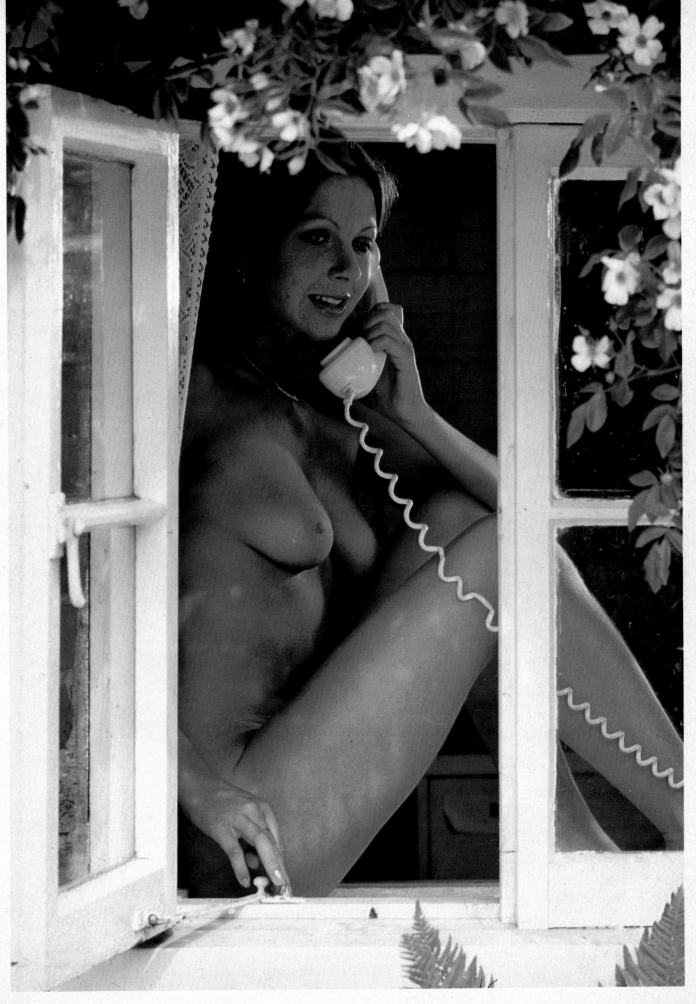

If you require softer lighting, diffuse the sunlight by placing tracing paper or a plain curtain over the window. The location of the window dictates camera angles and position of the model to some extent, so keep this in mind when checking the area.

The best way to control the *direction* of the light as it appears in a photograph is to move the camera and model. With the window behind the camera and the model facing the window, the light will be soft. Because light fills in shadow areas, there is little *modeling.* If you imagine a line from the camera to the model, the line would be at a right angle to the window. This is *front lighting.*

Moving either the model or the camera so that line is no longer perpendicular results in more directional lighting from the side. This produces stronger modeling and more pronounced texture.

## CONTROLLING THE LIGHT

The simplest and most useful accessory for daylight photography indoors is a large

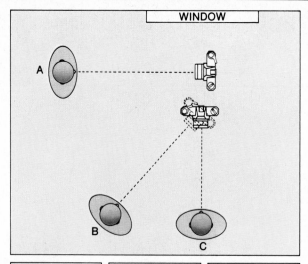

◄ Modeling is the way light creates an impression of form, making a two-dimensional photo seem to have three dimensions. This is governed mainly by the angle of light and the size of the light source.

This diagram shows strongest modeling with camera and subject near the window (A). The face is almost cut in half by shadow. Farther from the window, with the light at a less acute angle, shadows are weaker but give more subtle modeling (B). When the subject faces both light and camera, modeling is least (C).

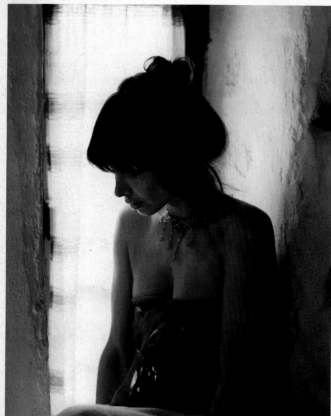

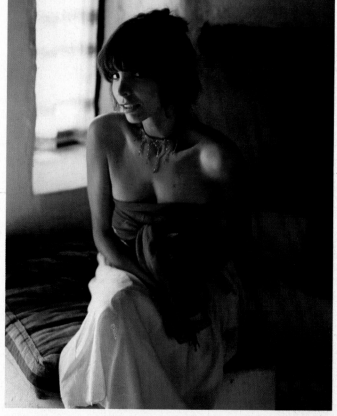

Michael Busselle chose a whitewashed cottage interior for these shots. At left, only the hidden part of the model's face is lit directly by the window. The rest is lit by softer light reflected from the walls. Right: Moving the model closer to a window, which is to the left of the camera and out of the image area, he created stronger modeling with darker shadows and more distinct highlights. The window behind her has little effect. Opposite page: Moving the model farther from a window at the right has the effect of spreading the light, giving a softer gradation from light to dark.

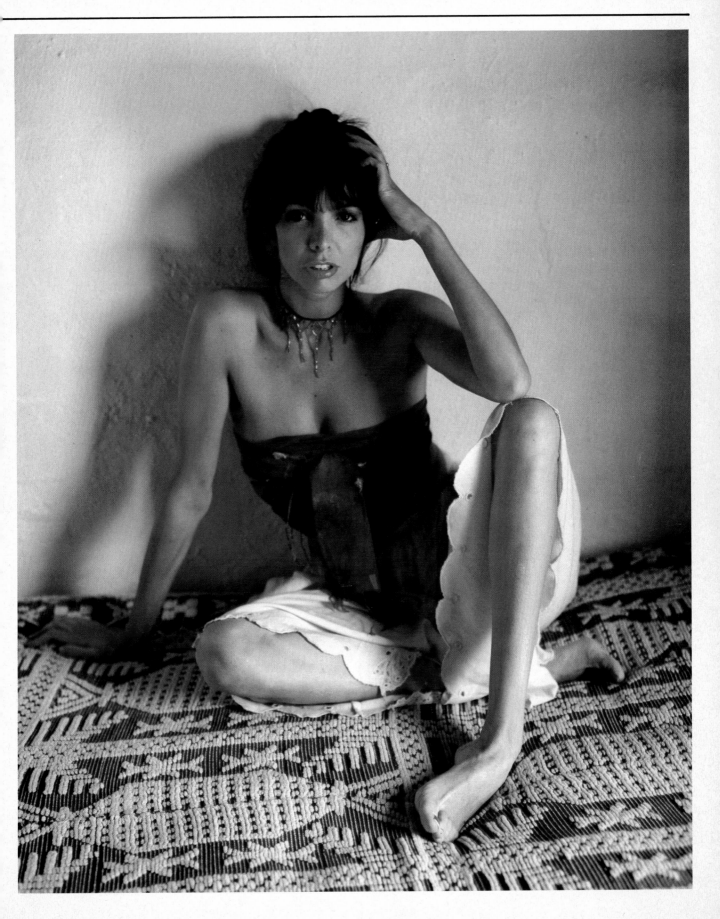

reflector to bounce light into shadow areas. By positioning the reflector close to the model on the side away from the window, and angling it to reflect the daylight, you have considerable control over the lighting.

If you paint the other side of the reflector black, you can also use it to shield the shadow side of the model from reflected light when you want a dramatic effect. This is particularly useful in a light-colored room with more than one window, where there may be too much reflected light for dark shadows.

Use silvered paper or fabric instead of matte white for an even more effective reflector. This tends to be more directional so its angle must be adjusted carefully.

Another "light" source is a mirror. If positioned behind the model, a large mirror can produce a rim-lit effect with the reflection of the light source.

Light from a table lamp can create additional interest. Although it records as an orange tint on daylight-balanced color film, this sometimes works well, especially when the lamp itself is included in the picture.

## USING FLASH

You can control the lighting contrast with an electronic flash unit. Flash light closely matches the color temperature of midday sun, so it mixes well with daylight when you are shooting with daylight-balanced color film. The light from the flash should supplement the window light, acting in the same way as a reflector. Be sure the flash exposure is one or two steps less than would be required for good exposure of a flash-only picture. This way, the flash adds light to shadow areas, lowering lighting contrast.

Use the flash on the camera or as close to camera position as possible. This way, you won't create secondary shadows due to the location of the flash. For example, if you do not keep the flash close to camera position when doing a portrait of your model's face, two separate shadows from her nose may result. This is not a pleasing effect.

Here's how to determine exposure for flash fill: Take a meter reading of the existing light. For example, assume the reading is 1/125 second at $f$-8. Then calculate the flash exposure using the flash guide number (GN). With a guide number of 80 feet (25m) and the flash about 10 feet (3m) away from the subject, the *normal* flash exposure would be $f$-8. To underexpose with the flash by two steps, use a lens aperture of $f$-16.

To maintain the correct exposure by the existing light with this aperture, adjust the shutter speed for one or two steps *more* exposure—1/60 or 1/30 second. You can reduce the flash exposure by diffusing it with tracing paper or bouncing it from a wall. Then close the lens aperture a half step to compensate for the combined effect of flash and ambient light.

The camera shutter *must* be set to a flash-sync speed. Typically, this is 1/60 second or slower. Some cameras sync at 1/90 or 1/125 second. Check your camera manual to find flash-sync speeds for your camera model.

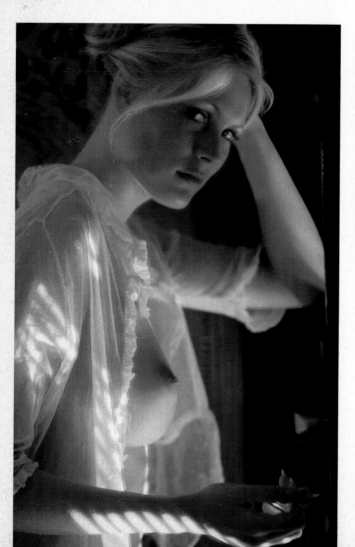

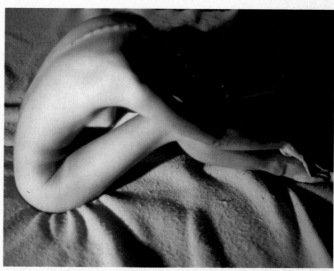

▲ Here, the directional side light emphasizes the form of the body, which is depersonalized because the face is hidden. The side light also picks out the folds in the background. The folds lead you toward the figure. Photo by Ashvin Gatha.

◄ When window light is insufficient, supplement it. Electronic flash blends unnoticeably with existing daylight at midday when used properly. Michael Boys shined a supplementary light through a slatted blind for this effect. The model's white blouse acted as a reflector, throwing a softer light on her face.

## SOFT FOCUS

Excessive lighting contrast is one of the most common problems with window light. Although you can do a great deal to control it by the methods just discussed, you can also reduce lighting contrast by using soft-focus lens accessories. These devices can create a romantic mood in your photographs.

These accessories spread image-forming light into the shadow areas of the image. This makes shadows reproduce lighter. The diffusion effect also makes an image less sharp. Many soft-focus accessories are available. The degree of the effect varies.

▶ John Garrett used a soft-focus lens accessory for this effect.

▼ Instead of using a soft-focus lens accessory, Garrett breathed on the lens to create this shallow two-dimensional effect. He underexposed the film by two steps and overdeveloped the film to accentuate grain.

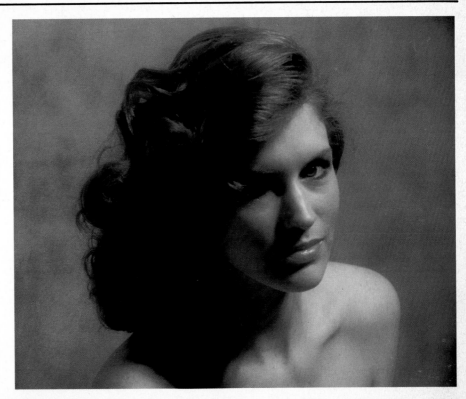

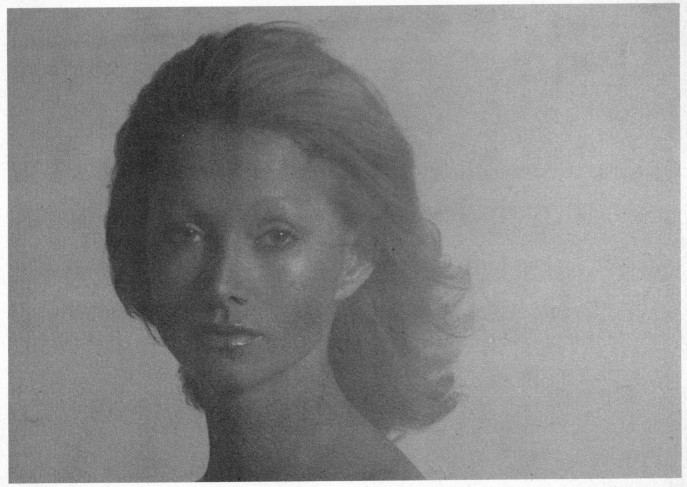

# The Nude Indoors

One of the best places for indoor figure photography is near a window in your home. This is economical and requires minimal fuss and organization. Generally, you don't need a lot of space. You usually have to work with the model close to the window because the intensity of the light falls off dramatically as the model moves farther from the window.

## LOCATION

If you can't get far enough away from the model, shoot diagonally across the room, or through an open door. No one will know the difference as long as the door frame is out of the image area. Or, you can accept the limitations of space and move in close to photograph form, shape and abstracts.

**Staircase**—Another alternative is to use a staircase. The angular shapes contrast with the soft curves of the human form. Lighting on the stairs may vary from top to bottom, giving the impression of depth in the photo. Stairs also give you the choice of two dramatic angles—looking down at the model or looking up.

**Bathroom**—A bathroom with frosted glass and white tiled walls offers good lighting that results in good modeling, even in direct light. And there is usually enough reflected light to act as fill. You also have many props, such as a shower, bathtub, water, soap and bubbles. It's a natural place to take nude photographs. But be aware that light reflected from colored tiles may create a color cast on the skin tones in color photographs.

## WORKING AT HOME

It is easier to persuade friends, relatives or even a neighbor to model when you are working at home. For example, young mothers may be willing to pose with their babies. You must make your intentions

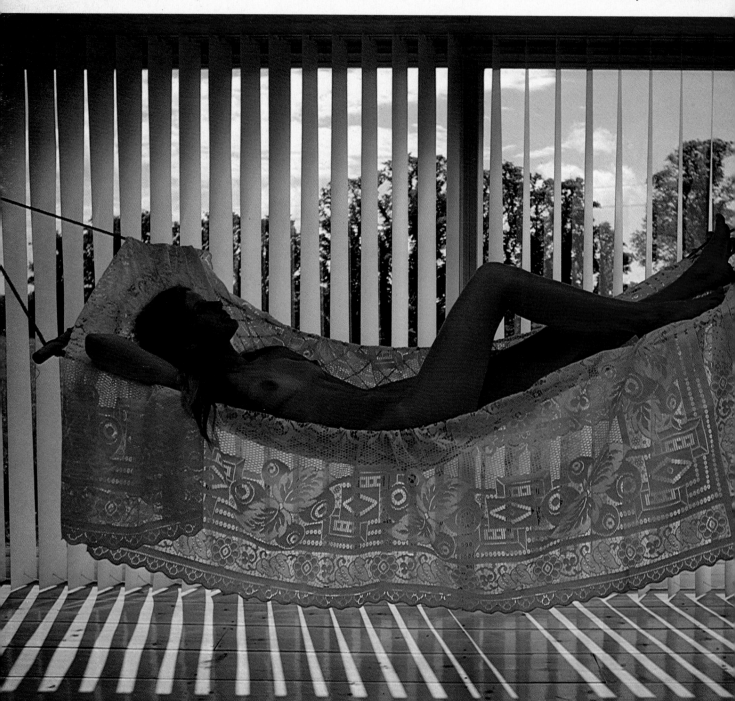

► The mood of a photograph is affected by location, props, light and the attitudes of photographer and model. Adding an unusual element, such as the balloon, gives the model something to do and adds to the composition. Photo by Michael Boys.

▼ Although a large window and lots of space are desirable, they are not essential. If you need room to move around because the room is small, shoot through a doorway. Photo by Michael Boys.

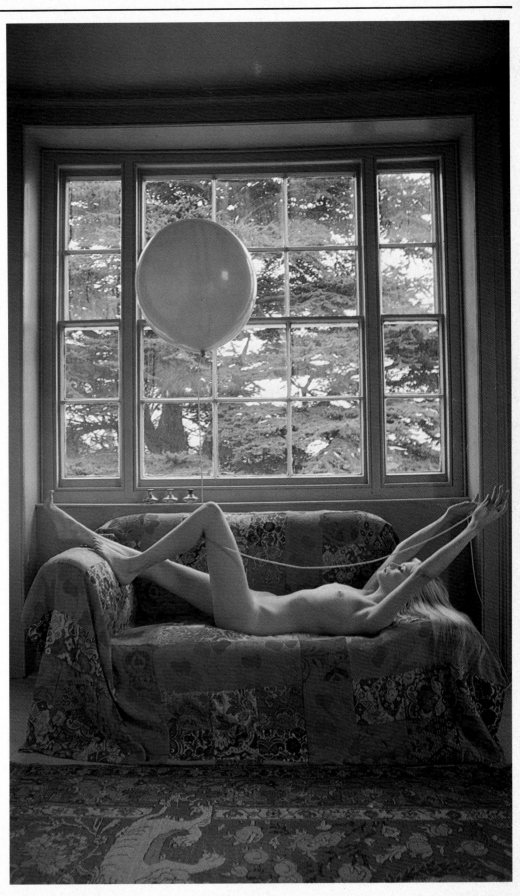

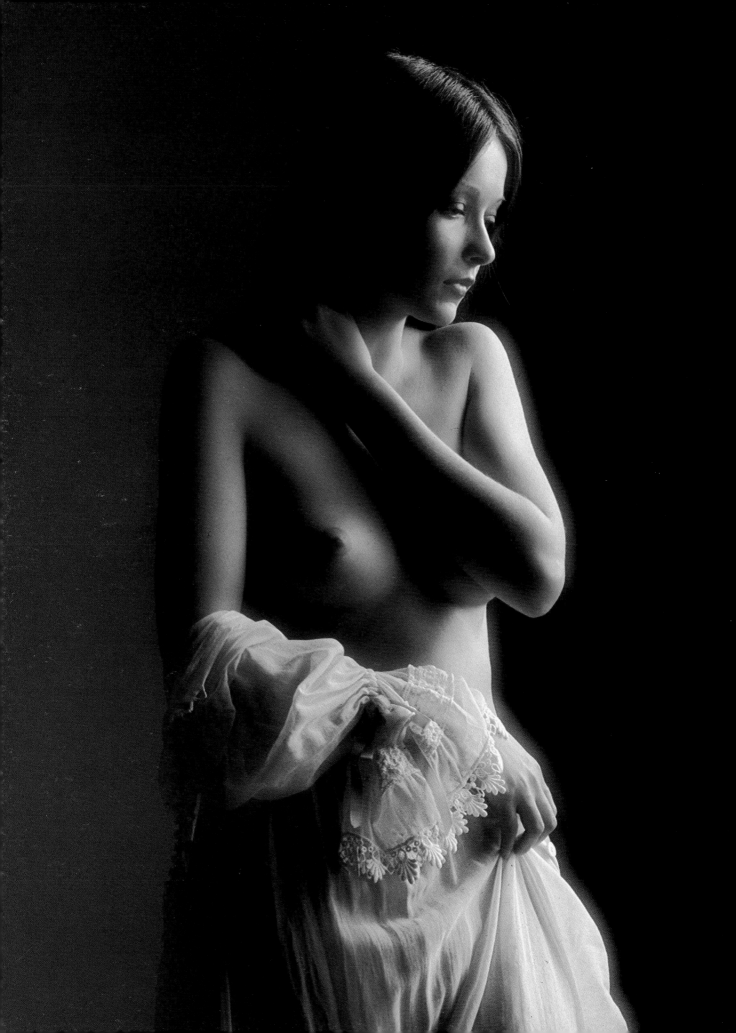

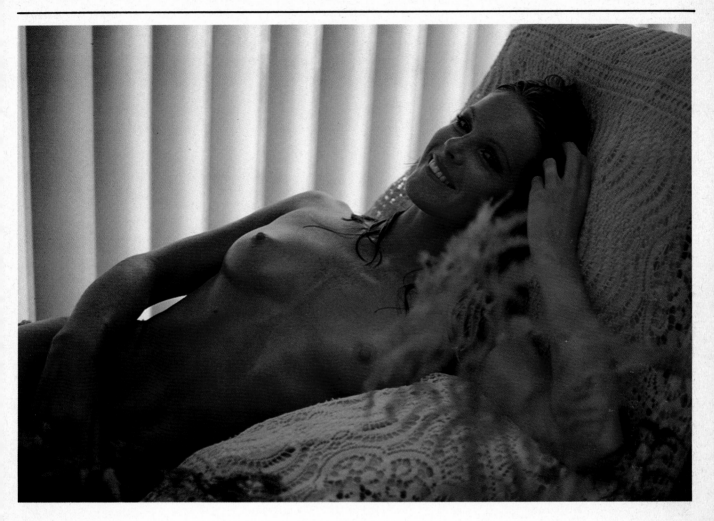

▲ The natural diffused light from a north-facing window reveals form well. You can diffuse direct sun by hanging white net curtains or tracing paper in front of the window. Photo by Michael Boys.

◄ The closer the model stands to a window, the greater the contrast between highlights and shadows. Lessen the contrast by moving the model away from the window or by reflecting light into shadow areas. Photo by Sanders.

clear from the beginning. As mentioned earlier, select examples from books and magazines to show the model what you have in mind. If you already have a portfolio, show it to her. These will also help her during posing.

If you do not know anyone suitable or willing to model, you may have to hire a professional. You can then show the resulting photographs to amateur models as proof of your abilities.

Professional models seldom come to a private house—at least, not until they know the photographer. Start with an outdoor session or rent a studio for a short time.

Again, it is important to establish mutual confidence and respect, and to decide whether you can work well together. Models booked through agencies are expensive, so a preliminary discussion about the details of the photo session can save time and money.

## LIGHTING

The ideal natural lighting for good form and modeling is north light. A full-length window is best for photographing a standing model. Otherwise, the windowsill may cast an obtrusive shadow.

An excellent technique is to have the only light reaching the model at an angle of about 45° to the camera axis. Position the model on one side of the window and the camera on the other side. Have the model at least 6 feet (2m) away from the wall so the light does not illuminate the background. For a silhouetted profile, the model should be directly in front of the window.

## LIGHTING CONTROL

Even with a diffused light source, shadows may lack detail if you base exposure on the lit areas. This results in a *low key* and contrasty effect.

However, most photographs of people should show some shadow detail. Sometimes you'll have to add fill light from a reflector to get that detail in the shadows. Use the white card mentioned earlier to reflect the light. Or, you can make an even more efficient reflector by covering a card with aluminum foil. The closer the reflec-

tor is to the shadowed side of the model, the lower the lighting contrast.

For photography with b&w film, you can use household lamps or photofloods for fill light. With daylight-balanced color film, household lamps will create an orange cast. Of course, the cast can be used to your advantage if that is the effect you want. If not, use a reflector or flash as the fill source.

When using fill lighting, bounce it off a white wall or ceiling for soft illumination. The fill light must be weaker than the window light. It should not overpower the the window light, which is the main light source.

Indoor exposures are usually longer than those made outdoors. Use a tripod

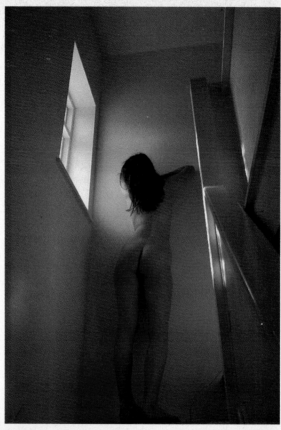

◄ When working in a confined space, a wide-angle lens is helpful. But be careful to avoid distortion. Photo by Per Eide.

► Soft light from a living room window illuminated this picture. Stuart Brown pinned a piece of black felt to the wall for a plain background, and used a soft-focus accessory to diffuse the image.

▼ Although this photograph was made with a wide-angle lens, there is no distortion because all of the elements are essentially in the same plane. Photo by Caroline Arber.

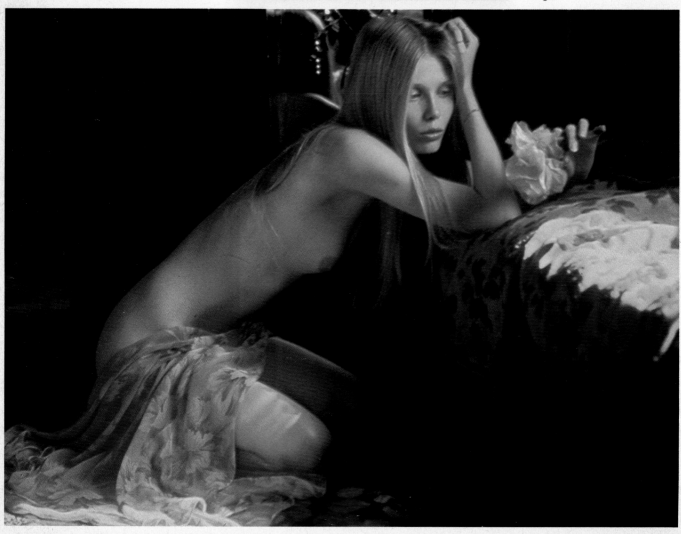

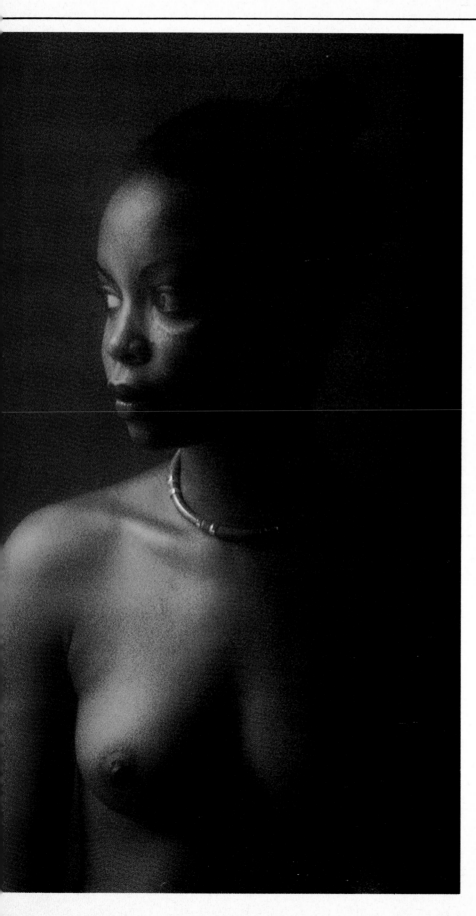

and cable release on the camera if necessary.

Camera aperture should be large enough to have the background out of focus. Backgrounds are not a problem if you don't light them. They will generally reproduce dark and will not detract from the main subject. To do this, position the model about 6 feet (2m) or more from the background.

## LENS CHOICE

Your choice of lens depends mainly on how much space you have and how much of the model you want in the photograph. A good starting point is a 100mm lens on a 35mm camera. It allows you to stay far enough away from the model to avoid distortion and offers flattering perspective. A 70mm to 150mm zoom lens is good for all poses, from full length to head and shoulders.

You may have to use a wide-angle lens in a confined space. If so, don't get too close. Keep all the parts of the model on the same plane, approximately the same distance from the lens. If you don't, those portions of her body closer to the lens will look relatively larger than others. This is unflattering distortion. Distortion can occur with any lens. It is discussed in more detail beginning on page 57.

Because the wide-angle lens covers a larger area, you'll have to pay more attention to room furnishings. Move distracting items out of view.

## MORE THAN ONE MODEL

The even light from a large source such as a window is a benefit when you want to photograph two or more people. You don't have to worry about one subject casting a shadow on another. Have one individual dominate the composition by placing her closer to the window.

Be sure of yourself when setting up poses. Two models make your task at least twice as difficult. Make test shots in advance if you have any doubts about exposure, focusing or lighting. Use friends for the tests. When doing the actual photography, make more than one exposure of each setup at different *f*-stops. This is called *bracketing*. It helps guarantee you'll get usable photos that are properly exposed. Also, if you take extra shots, you should get some with everyone's eyes open and expressions just right.

Be sure each model knows how the photos are going to be used and how you expect her to interact with the others when posing.

# The Nude Outdoors

One of the easiest ways to start photographing nudes is to do it outdoors.

**Two Advantages**—There are two major advantages to outdoor nude photography. It is sometimes easier to persuade people to pose, and the lighting and props are free. Available light will be discussed in detail later. Models may be more comfortable posing nude outdoors because many find the atmosphere of a studio or any other indoor area too inhibiting.

## LOCATIONS

Privacy is essential. Neither you nor the model can concentrate if there is a fear of interruption by outsiders. A good location is a secluded private garden. If you do not have one, you may be able to rent one. Some camera clubs have listings of such locations and use them for group sessions.

You must keep in mind that local ordinances may restrict nudity on public property. For this reason, concentrate your search for locations for photographing nudes to privately owned property—and you should have permission of the owner before proceeding. It is also not advisable to photograph people sunbathing or swimming in the nude without their permission.

Woods and beaches with dunes and tall grass offer privacy and varied backgrounds. Proper timing is another way to avoid people. Locations that are crowded on weekends may be empty at other times. Many spots, even in well-populated areas, are deserted early in the morning.

Do not use private property without permission. You may attract an unexpected, and unwanted, audience and possibly law enforcement officers.

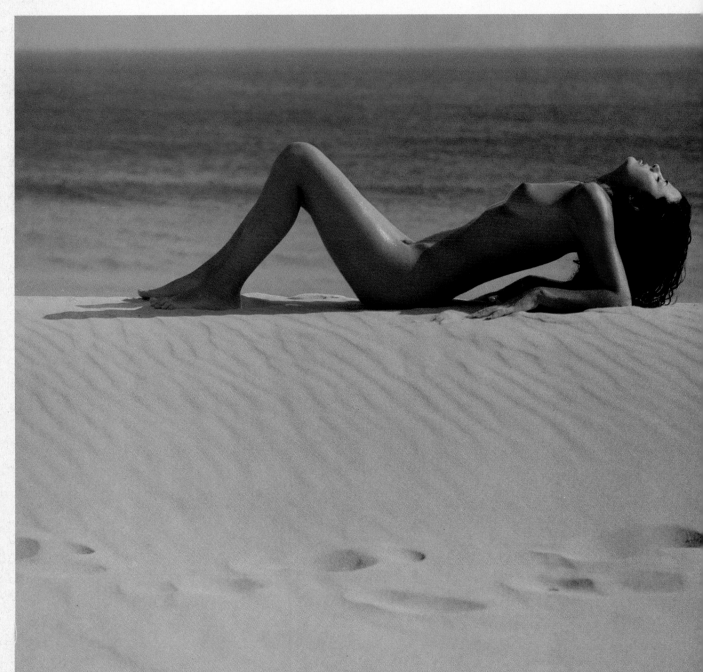

▼ Begin simply. A beach is a natural place for nude photography. It is also easier for many people to pose in the open than in the confines of a studio. And the lighting is free! This simple pose is set off by the horizon lines, the top of the dune and the footsteps in the foreground. Photo by H. Blume.

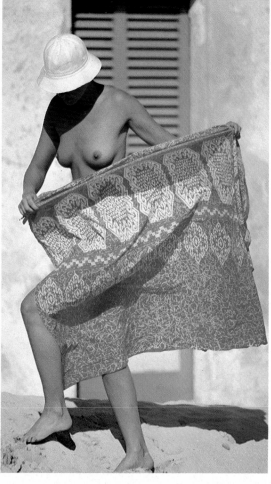

▲ Keep your sense of humor! Nude photography should be an enjoyable experience for both you and the model. Don't take it too seriously, and keep the camera ready for candid shots. Photo by Andreas Heumann.

**Camera Clubs**—If you join a large camera club, participate in a group session, as discussed earlier. Such an experience can help you overcome your initial shyness, and also helps you meet models. If you see one you'd like to work with, try to arrange a private session. You may also want to use the same location.

## LIGHTING AND EXPOSURE

Visit the site you've chosen in advance. Study the sun's effect at different times of day. Look at several locations, make a list of detailed information about each and plan ahead for your photo sessions.

Make some test photographs of a friend or a neutral-colored object. Examine these carefully for any color cast. Light changes color during the day. In the early morning and late afternoon, light has a yellowish cast.

In addition, reflected daylight picks up the color of the reflecting surface. For example, sunlight reflecting off grass may give a green cast on the subject. Or the model's skin may look red if she is on a red blanket.

If you use color negative film, this slight color cast can be corrected during printing. But with color slide film, corrective filtration may be necessary. If you have any doubt about color cast, it is advisable to work with negative film.

▼ Start with a basic portrait. Pay attention to the model's character. Photo by Lorentz Gullachsen.

**Filtering Color Casts**—You should always correct "cold" casts such as green and blue because these colors make people look ill. Use color-compensating (CC) filters. These are usually available in six colors and various strengths. The letter on the filter indicates color and the number indicates strength. A CC05Y filter is lighter than a CC30Y filter. Usually a CC05 or CC10 strength in the right color will correct a color cast. Yellow corrects blue and magenta corrects green.

It's usually not necessary to correct the warm orange tones of the late afternoon sun because most people like the effect on skin tones. To correct a blue cast, use Wratten series 81A, 81B or 81C, or CC05Y yellow filters to make the skin look more natural. For more information read Carl Shipman's *SLR Photographers Handbook*, also published by HPBooks.

**Diffused Sunlight**—A slightly overcast or hazy day is ideal outdoor lighting for figure work. The clouds or haze diffuse direct sunlight and act as a large light source, casting light from all directions. Lighting contrast is not too high. Fill lights or reflectors are usually not necessary for shadow detail because the shadows are "opened up" by light from all directions. Even when the sun is diffused by clouds, its light is still directional and results in pleasing form and modeling.

Don't cancel a session if the sun is too strong. Use a small electronic flash on the camera to fill in heavy shadow areas. Or, use elements around the location, such as sand, a white wall, a rock or other light-toned object to reflect light into dark areas. If necessary, improvise a reflector by hanging newspaper on a nearby tree or car.

Do not overexpose color slides. Resulting skin tones will be very pale. Slight underexposure of about one-third step is preferable. With both b&w and color negative materials, the printing process can compensate for some error in exposure. However, you'll usually get best results with proper exposure.

## WORKING WITH MODELS

Ask your model to wear loose fitting clothing before a session. Marks on the skin caused by elastic straps are distracting. Have her remove all rings, earrings and other jewelry unless they are to be elements in the photograph. Otherwise, they attract too much attention—especially if they reflect the sun.

Be aware of an uneven sun tan. It will stand out in the photograph. Use makeup to soften the lines or have some "instant sun tan" lotion handy, just in case.

**Plan Ahead**—Research the location and decide in advance on some poses. If you are properly prepared, the first session shouldn't be longer than two or three hours. This is long enough for you to make a good variety of exposures. Don't forget to include makeup time in your plans. And look after your model's general comfort.

▶ Have a clear idea of the results you want before you start, but allow for spontaneity during the session. Photo by John Kelly.

## POSING & COMPOSITION

Know what you want beforehand so you can give meaningful directions to the model. Then she will develop confidence in you.

Amateur models often find it difficult to know how to hold their hands. Use the natural props of the location and suggest ideas such as playing with sand, tugging at a branch or leaning on a rock or tree. Water is an interesting prop—especially if the model will take a dip. Keep a towel and dressing gown handy.

These are obvious and easy-to-follow ideas. Don't expect too much from your first photographs. Figure photography is not as easy as it may seem.

## FILM

If you are going to use a tripod, choose the slowest film possible for the prevailing light conditions. Slower films have a finer grain and you can enlarge them easier without losing sharp, well-defined features. The tripod helps steady the camera so the image will be sharp.

If you don't want to use a tripod, choose the fastest film that allows you to hand-hold the camera. In bright sun, you can use a slow-speed film, such as ASA 64. On an overcast day, use medium-speed (ASA 200) film. Use fast film (ASA 400) only when necessary.

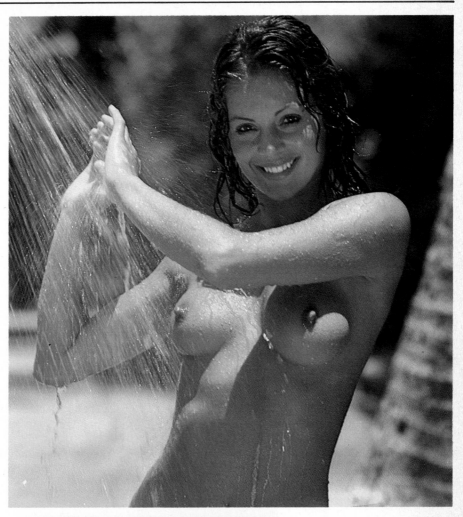

▲ Water, sand and leaves are natural outdoor props, and can be used to help an inexperienced model relax. Photo by H. Blume.

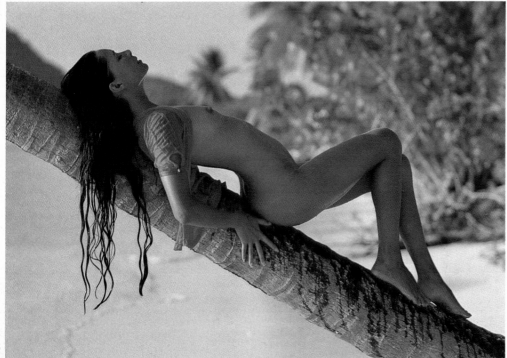

◄ Research locations well. Note where the sun will be at different times of day. Watch for areas that may reflect light or cause a color cast. Skin tones should look natural. A red cast from the setting sun is usually acceptable because it gives a feeling of warmth, but green or blue casts should be corrected. Look for large rocks, trees or areas with strong texture that will complement the rounded lines of the human form. Photo by Donald Milne.

# Abstracts: A Different Approach

Most photographs are planned to be identifiable representations of a particular subject, interpreted and presented the way the photographer sees it. Especially in nude and glamour photography, the purpose of the photograph is often to project the model's personality as well as her appearance.

Even so, the nude body lends itself to more abstract images, in which the identity of the subject becomes less important than the shapes and tones created in the photograph. The human body is a good subject for abstract photographs. The shapes and contours of the body vary considerably not only from one model to another, but also dramatically within the same body—the slightest shift in position or change in muscle tension can create a completely new "landscape."

Abstract nudes and landscape photography are similar in some ways. As with landscapes, different forms of lighting on the nude body can reveal new and constantly changing lines. The texture of skin also creates different images. Although conventional nude and glamour photography require the subject to be "flattered," abstract nude photography has no such constraints because the face is not important to the composition.

For an abstract, you present a specific feature of the subject so it is isolated and out of context. For example, you can crop the head or not show the face, or use techniques that actually disguise the nature of the subject.

## CLOSE-UPS AND CROPPING

The most obvious of the various approaches to nude photography is the use of tight framing. By isolating a small area of the body and composing a picture from the shapes and contours within a specific area, you can produce images that range from intriguing to erotic. Extreme close-ups and near-abstract nude photographs can be far more effective than conventional "cheesecake" poses.

You can accentuate the curves of a body and the soft, supple quality of skin and hair by concentrating on these areas. The work of photographers Helmut Newton and Jeanloup Sieff are good examples of abstract nudes that have a strong erotic appeal.

## LIGHTING

The effect of light can provide virtually limitless photographic effects as if the body were a miniature landscape where both the sun and the landscape itself can be moved at will. Although you can use

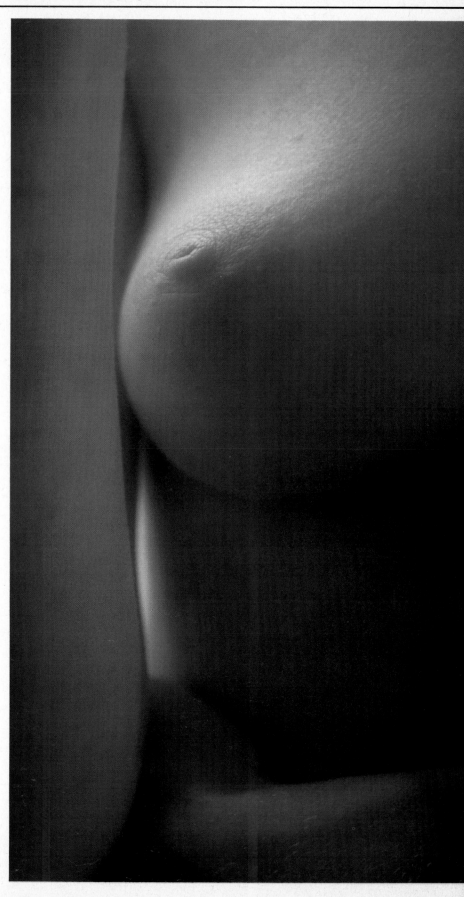

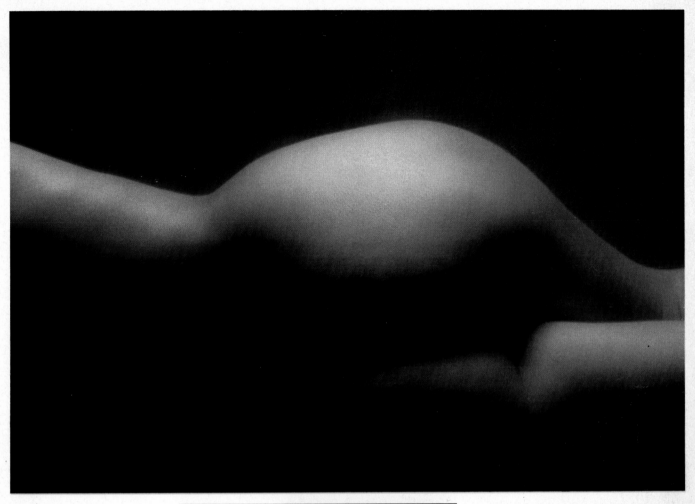

▶ Diffused daylight illuminated this photo by John Garrett.

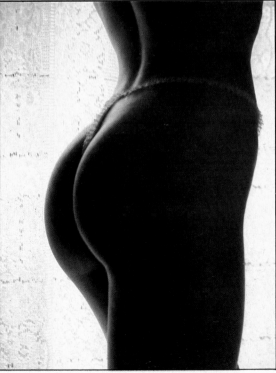

▲ For this photograph, John Garrett diffused light from an electronic flash, which was located above and slightly behind the model. He blocked stray light from the background to keep it dark, and underexposed the film to lose detail in the shadows.

◀ Here, Garrett aligned the vertical shape of the girl's arm with the side of the frame, emphasizing the contrasting shapes and angles. He bounced the flash from an overhead reflector to create the highlight.

daylight effectively in abstract nudes, the full potential of lighting can only be exploited when studio or portable lighting is under your control.

For most situations, you don't need many lights. Because there is not a wide range of tones in the human body, you can increase photographic impact by using contrasty light. This way there are brightly lit areas and dark shadows. This yields an image with a wide range of tones. A spotlight is useful for producing dramatic, high-contrast effects, but these effects can be achieved even with a conventional household lamp.

A tripod is an invaluable tool. Moving the model, light source or camera even slightly can create dramatic changes. If

you keep the camera in one place, slight adjustments in focus are all that are necessary to make the exposures. Move the light source or model when needed. For example, when working with strong directional lighting, especially close up, it is preferable to move the model to change the effect rather than the light source or camera.

## TECHNIQUE

Good camera technique is vital for abstracts because the impact of such photographs depends to a large extent on the quality of the image. When texture is a prominent feature of the subject, for

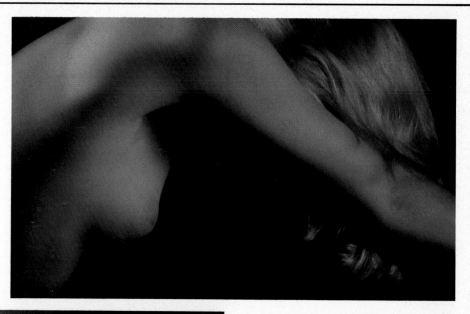

▶ John Garrett included the model's hair as a contrasting texture here.

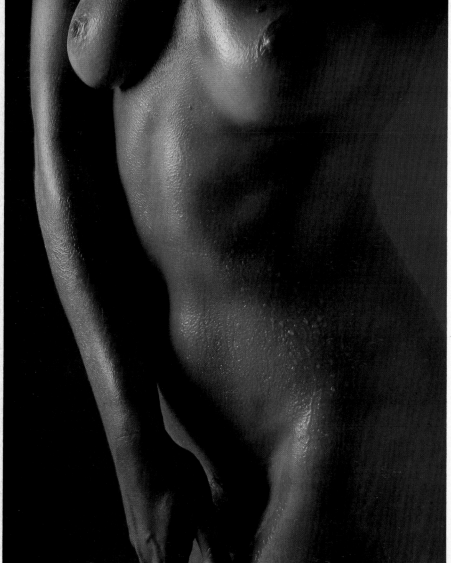

◀ Mike Busselle's model put oil on her skin and then sprayed it with water. Side lighting helped accentuate skin texture.

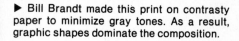

▶ Bill Brandt made this print on contrasty paper to minimize gray tones. As a result, graphic shapes dominate the composition.

example, the image must be as sharp as possible. You must focus the lens accurately and choose a lens aperture for adequate depth of field. Check by looking through the viewfinder while pressing the depth-of-field preview button if your camera has one.

When working very close, this often means using the smallest possible aperture. With tungsten lights or daylight, you need longer exposures—another good reason for using a sturdy tripod.

The tonal range and color quality of abstracts are also important. Why bother to carefully light and compose a picture if the final effect is destroyed by an exposure setting that results in washed out or muddy highlights or shadows without detail? Precise exposure is crucial. To be sure you'll get a good photo, bracket by making additional exposures at about 1/2 step either way. You can treat this type of subject as a still life because you don't have to worry about the model changing facial expressions.

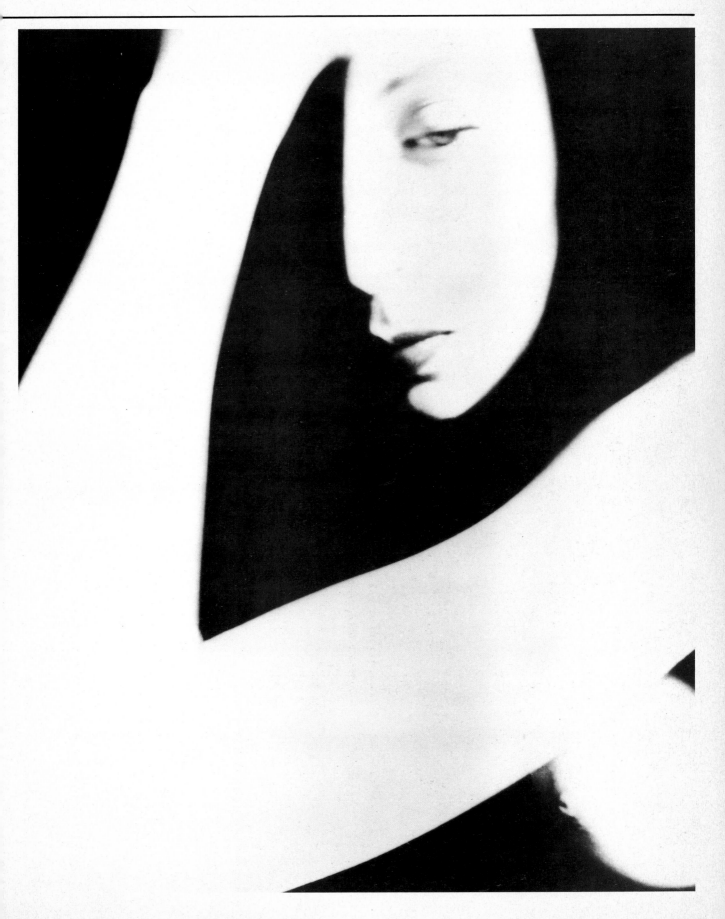

## CAMERA ANGLES

Another way to create an abstract image with a nude model is to use different and unexpected camera angles. Common objects can become almost unrecognizable when seen from an unfamiliar viewpoint. Again, it is usually best to move the model rather than the camera.

Generally, we look at people more or less from the front, eye to eye and usually in a vertical position. It is surprising how different and interesting a body can look when viewed from the toes up or from the top of the head, for example. Instead of standing, have your model sit, crouch, lean, lie down or any other position you feel will work. Such angles are simple to create by moving the model, especially when you are working close up and the background is either hidden or cropped out.

## LENSES

You can also create unusual perspective effects with long-focus or wide-angle lenses. A long lens enables you to work from a distance and still frame the image tightly. Coupled with a viewpoint along the length of a body, for example, this can create strange juxtapositions of limbs, and unexpected effects.

A wide-angle lens allows you to work extremely close, with part of the body in the foreground. Because of the wider field of view, you can still include other areas, and can take advantage of the distorted perspective created by the lens.

## ATTENTION TO DETAIL

When isolating small areas of the body and lighting to accentuate skin texture and contours, be aware of blemishes or imperfections. These tend to be exaggerated on film. Don't hesitate to ask the model to use a little makeup to cover those areas.

Skin color can be a problem when shooting on color slide film. Models with very fair skin may not look good on film. You can overcome this to some extent with proper lighting and the use of a filter such as a CC05R. Another method, as mentioned earlier, is to rub tinted suntan oil into the skin. This produces an attractive sheen.

When your model is posing in water, or will be wet for a special shot, watch for goosebumps. This may sound funny, but you may not notice them when photographing. Under certain lighting conditions, such as when the skin is lit from the side, they may be accentuated in the photographs.

▶ Per Eide produced this interesting composition by framing so his model appears in the corner of this imposing landscape.

▼ John Garrett used the human figure for its shape. He lit the scene from beneath and behind. A sheet of black velvet above gives the bottle its dark rim. Exposure was based on reproducing the background as a middle tone. This silhouetted the foreground.

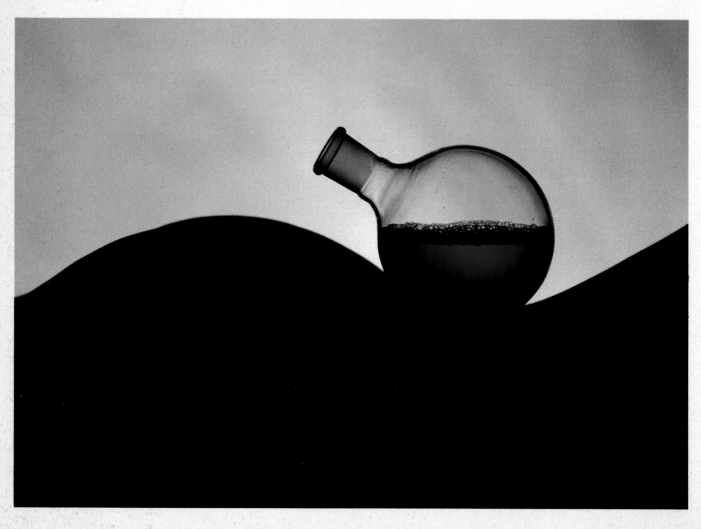

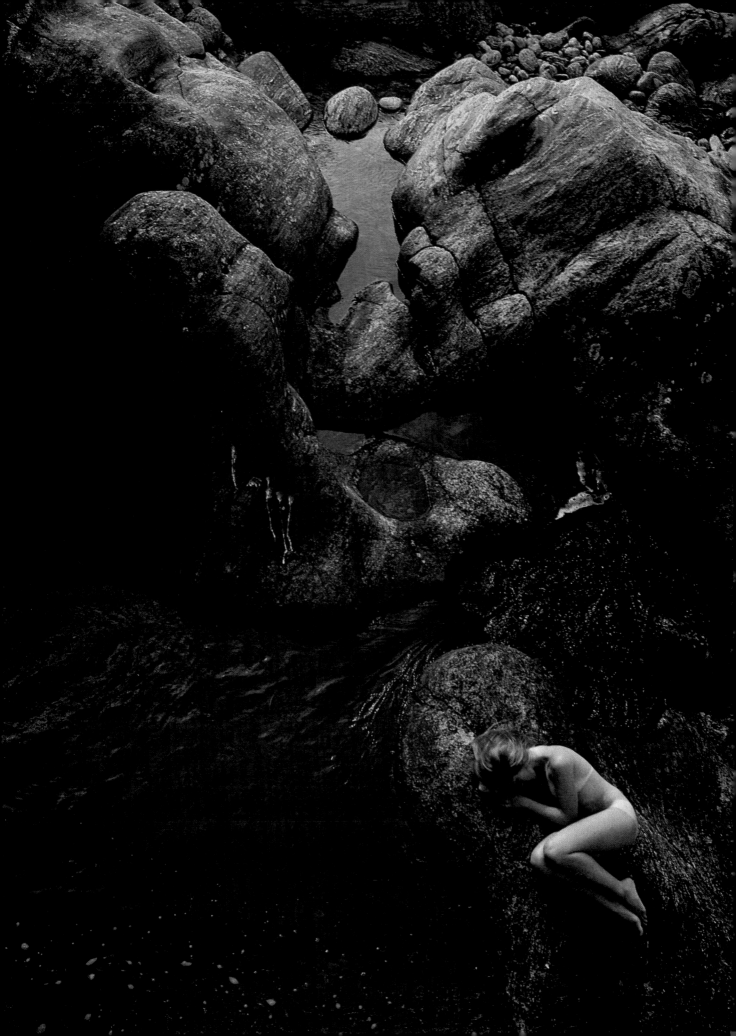

# Glamour Photography

Glamour photography offers the viewer a feeling of romance and beauty. The essential quality of romantic glamour photography is a gentle soft mood in the image, where there are no sharply defined edges. The image has a dreamy look to it.

Some early photographers deliberately produced soft images, taking their inspiration from the school of romantic painters, such as Turner. Pointillist painters like Seurat formed soft images by an accumulation of tiny points of color. The effect is similar to the grainy pictures of Sarah Moon and Deborah Turbeville, produced by pushing the film and extending the processing, thus accentuating the grain of the film.

"Romantic" photography is based on the photographer's concept of idealized beauty. Fantasy and softness are important in such photos. Realism as represented by sharp focus and bright colors is minimized.

▲▶ Diffused window light gives skin a soft sheen without creating harsh shadows. A soft-focus lens accessory complements the effect. Photos by David Hamilton.

## THE MODEL

Well-known glamour photographer David Hamilton searches the countryside of Scandinavia for models. For Hamilton, they must be slim, have long hair, fair complexion, and figures that are not fully developed. He rarely uses professional models because he feels they are too aware of their image. This awareness may be enough to break the spell he wishes to cast—that of romanticism and innocence. His models must appear to be unconscious of their beauty.

But not all photographers can afford to spend time searching for perfection. It is practical to realize that every woman is a potential model for this type of photography. It is up to you to find and exploit that potential. It may be in an expression, a pose or a movement. A special grace or gentleness can make a woman a subject for pictures with a romantic mood. One of the greatest tests of the success of the photograph is whether it appeals to other women.

The model's hair and makeup should always look natural. Her hairstyle should be subtle and she shouldn't use bright lipstick or nail polish.

Poses should also look natural. Your model should not force a smile, nor should she be frowning; she should have a calm, reflective, peaceful look—unless you are trying to achieve a specific type of mood or attitude. The gentle mood is best suited to simple techniques—use a standard lens and an uncomplicated viewpoint and camera angle.

## PROPS

The model's clothes are important. The romantic image is best served by loose flowing garments with a smooth texture. Flea markets, swap meets and stores selling second-hand items are good places to find inexpensive, appropriate clothing. Or ask the model to search the family wardrobe for lace, silk and chiffon.

Props play an important role in creating the romantic effect. Use a few items to pinpoint color, or as a hint of a story behind the picture. You can try dried grass, a piece of jewelery, shells and pebbles from the beach, a book of poems, a half-written letter or a pencil sketch.

There should be only one dominant color other than the background, and that should be muted. For example, a pink scarf harmonizing with a bowl of pink roses is enough.

## BACKGROUND

Backgrounds are also important. You may want a monochromatic effect, with minimal shadow or strong highlight areas so they do not distract the viewer from the main subject. Indoors, use a room with white walls that reflect the light from the window. Don't include any strong direct sunlight in the image area. Outdoors, avoid harsh sunlight by working in the shade or on overcast days.

Another important element is the texture of the background. Visualize a photograph of a young woman, posed by tall grass in the late evening light. Then imagine her surrounded by fir trees in a forest at midday. The first can be a romantic image, the second too busy, with too much contrast.

## TECHNIQUE

Filters and lens accessories can help create the atmosphere you want. When the background includes tiny highlights, like the sparkle on water or the soft shine of silver jewelry, use a cross-screen accessory. This turns small, bright highlights into tiny stars, while slightly diffusing the rest of the image. Although special-effect filters change the image, they will not create the atmosphere for you—they are only part of good technique.

Some photographers create their own soft-focus effects by breathing on the camera lens before they make the exposure. This works sometimes, but the results are unpredictable. You can use petroleum jelly on a filter to achieve a variety of textures by smearing the filter diagonally or in circles, leaving a clear center spot. Never put it directly on the surface of a lens. Experiment with gauze or nylon stockings in front of the lens.

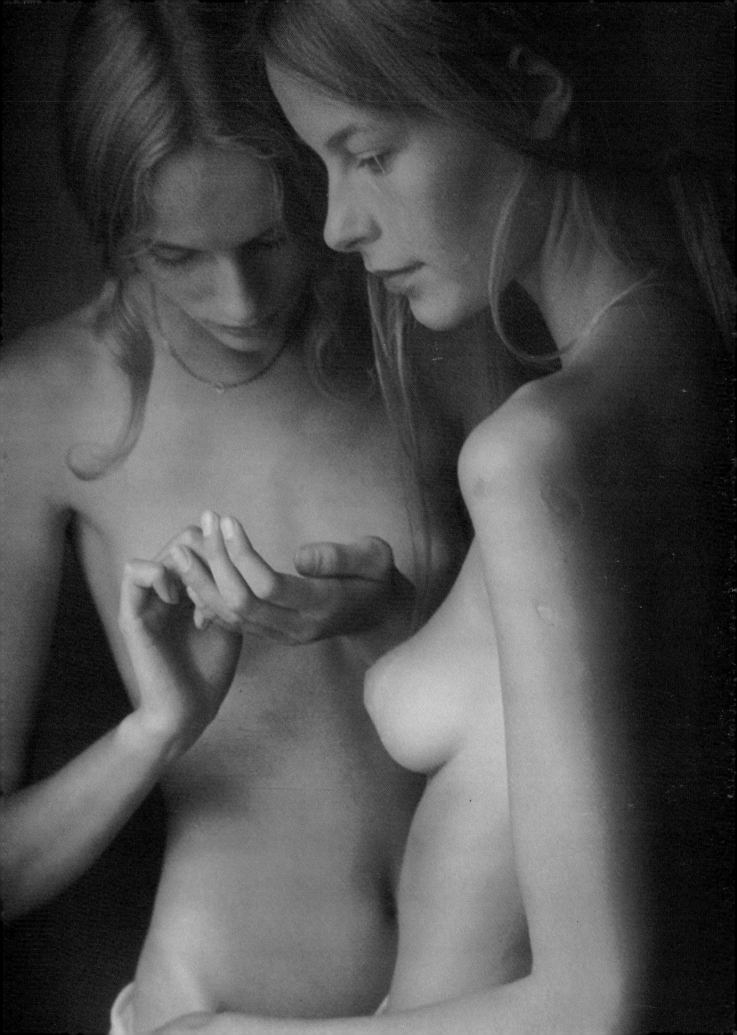

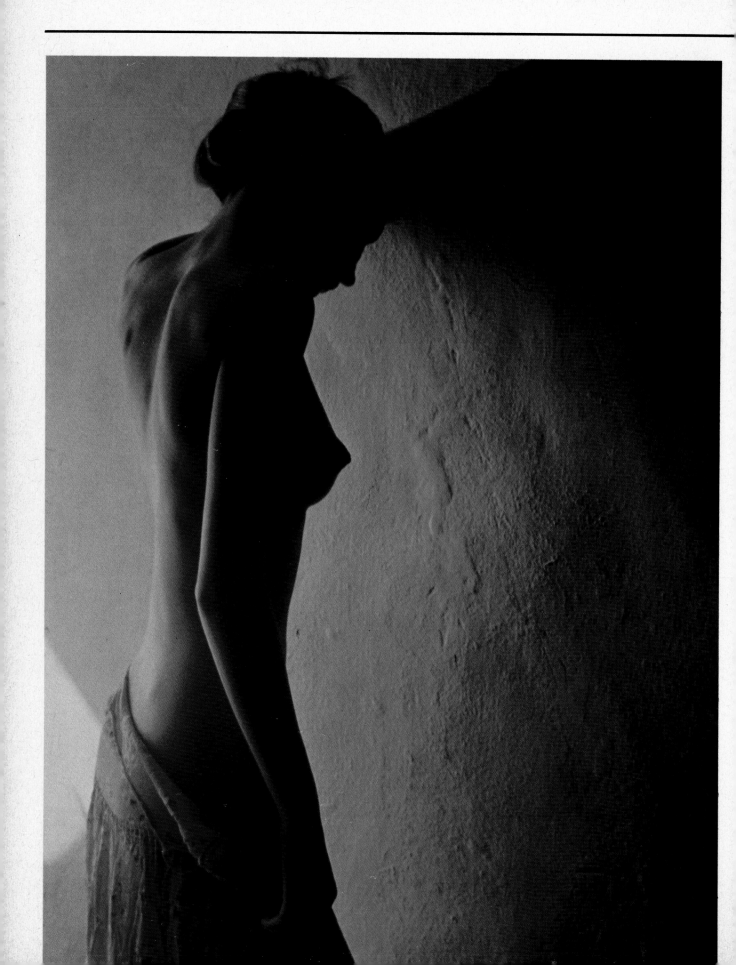

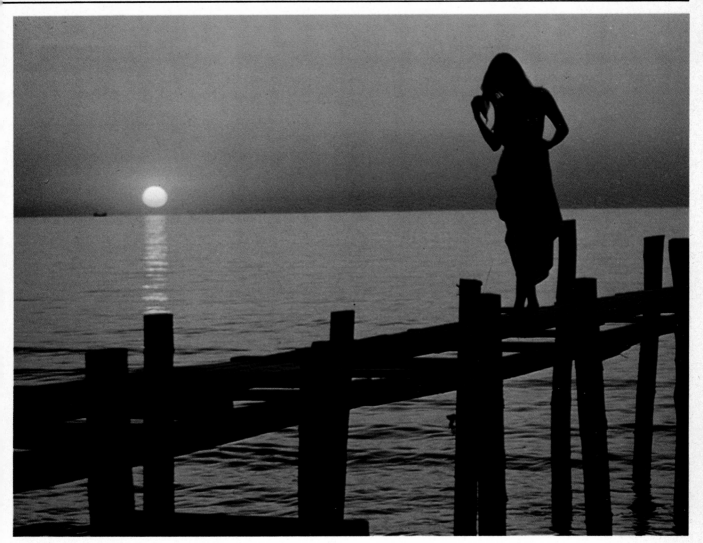

▲ The feeling of romance is heightened in a photograph if it contains some clue to a story. Showing little detail of the silhouetted figure, this image depends entirely on the mood of the sunset scene. The boat on the distant horizon suggests the reason for the woman's vigil on the shore.

◄ For the gentle, languid mood of romantic glamour pictures, use soft colors with similar hues. Avoid direct sunlight because it brightens the colors and the subject casts hard-edged shadows. Here, the warm muted colors allow the dark outline of the model to dominate the picture. Photos by David Hamilton.

## GRAINY FILM EFFECTS

A romantic mood in a photo is complemented by visible grain in the image. One way to get this in a slide or print is to use fast film and underexpose it. To compensate for this underexposure, you must extend development time. This procedure is called *pushing* the film. It works with both color slide films and b&w negative films.

Getting the effect you like requires some experimentation, but the general procedure is to underexpose the film one, two or three steps. Do this simply by setting the film-speed dial of your camera for two, four or eight times the normal film speed. Then expose according to the camera meter readings. Use low-level, low-contrast lighting.

With both b&w and color slide films, you must extend the normal development time. All other chemical steps are the same. For initial tests with b&w film, extend development about 30% for each step of underexposure. When using an E-6 processing kit to push-process film, follow the supplied directions.

If you don't process your own film, check with your local lab. They may offer this service. Kodak offers push-processing for an extra charge.

Another way to exaggerate grain is to selectively enlarge one section of a slide or negative.

# Secrets of Makeup

Few photographers realize how makeup can be used to improve portraits. If they think of it at all, they are content to photograph the model in her ordinary, everyday makeup, and are often surprised that the final result is less attractive than they had envisioned.

Photographic makeup does more than normal makeup. The tiny imperfections on the skin that you usually do not see or pay attention to may be accentuated when they appear on film. Makeup helps cover those blemishes. Makeup can also be used to accentuate the best features of the model's bone structure.

For your next portrait session, have the model apply makeup following the simple steps shown on these pages. Let her read this section. All the products used are ordinary cosmetics available in most department or drug stores.

A makeup table with a mirror, good light and a comfortable chair are essential. A ceiling light above the model's head is useless because it will cast shadows on her face and make highlighting and shading difficult to judge. The ideal setup consists of even illumination surrounding the mirror, shining straight on the face. If this isn't available, use two unshaded 100W bulbs on either side of the mirror.

Before she applies the makeup, the model should cleanse her face thoroughly, removing all old makeup. She should then use a skin freshener or toner and apply a thin layer of moisturizer to her face.

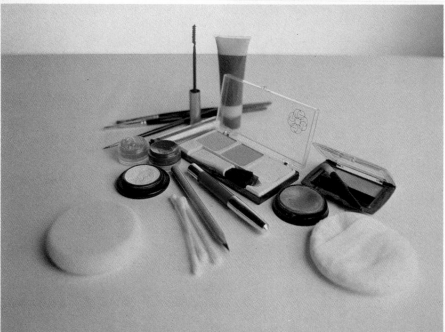

## WHAT SHE WILL NEED

The photograph above was taken when the model walked into the studio, before she put on her makeup. The one on the right shows her after she applied makeup. She used ordinary cosmetics for this transformation.

**Foundation**—Liquid foundation makeup, bronze cream blusher, pale highlight cream, cover cream, translucent face powder, powder blusher, shader, highlighter.

**Eyes**—Eyebrow pencil, eye makeup pencil, powdered eyeshadow, eye liner, mascara.

**Lips**—Lipstick, lip gloss.

**Accessories**—A powder puff, a cosmetic sponge, a selection of sable makeup brushes, a rouge brush, cotton swabs, tissues.

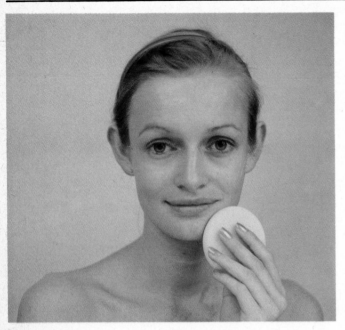

### 1) Foundation
Select a liquid or cream foundation that matches the skin tone. With a cosmetic sponge, blend a light, even film over the face. Include the eyelids and go back to the hairline and over the jaw onto the neck and throat. When the face is covered, continue to blend with a patting, stippling action until the surface is as flawless as possible. Add extra foundation where the surface is still uneven.

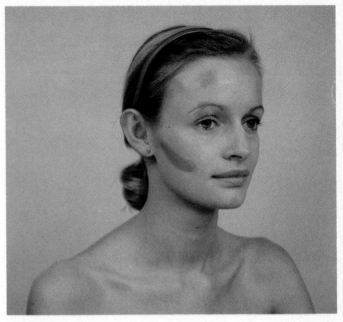

### 2) Shading
Shading and highlighting add visual depth to the face, preventing a flat look. Here you can see the shading cream before it was blended in. Note the upward curve of the shadow under the cheekbone and the touches of color on her brow and forehead.

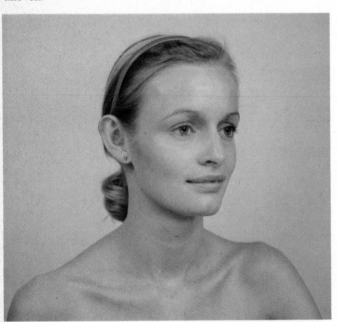

### 3) Blending the Shader
Blend the shader carefully with the cosmetic sponge, or with your finger. You want to soften the edges of the shaded area until the change from dark to light is scarcely visible.

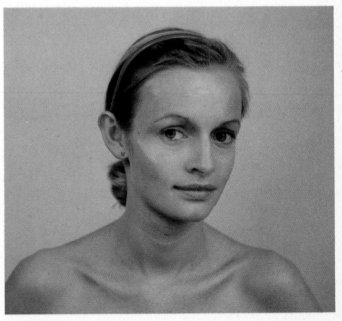

### 4) Highlighting
Highlighting accents bone structure. This is the opposite of what you've done in the shaded areas. Here you can see the highlight cream applied to the cheekbone before it was blended in. Here is the rule of highlighting and shading: Anything that should look smaller, make darker; anything you want to look larger, make lighter.

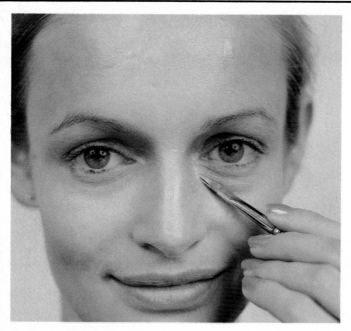

## 5) Covering Under-Eye Shadows

You can also use pale highlighting cream to hide unwanted shadows under the eyes. Using a brush, apply the highlight in the shadow area and softly pat away at the edges with the tip of your finger until they blend into the foundation. At this stage you may also want to use a beige cover cream to mask any obvious blemishes.

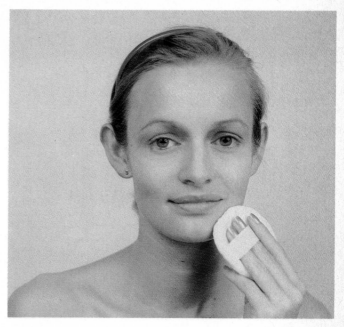

## 6) Powdering

With a generous amount of powder on a flat velour puff, fold it in half and rub the surfaces together until the powder is pressed into the texture of the puff. Pat the powder over the face until there is no shine. Before you powder around the eyes, be sure the makeup has not collected in the creases. If so, pat it smooth with a finger and powder the area to prevent this from recurring.

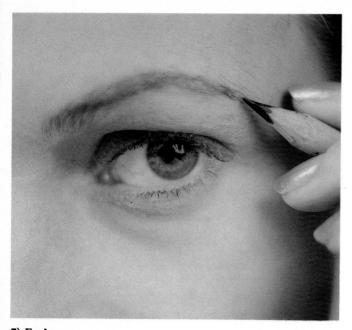

## 7) Eyebrows

Brush the eyebrows with a clean mascara brush, grooming them into the best possible shape. Then, with an eyebrow pencil, sketch in the brows with short strokes—like hairs themselves—starting immediately above the inner corner of the eye and following the natural arch of the brow to a point just past the outer corner. Lift the shape slightly as you get to the outer end.

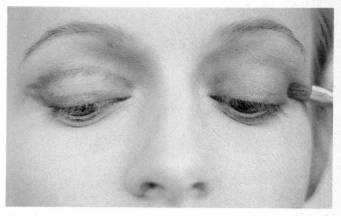

## 8) Eye Pencil

With a well-sharpened eye pencil, draw a wide line along the top lid, close to the roots of the lashes. Draw another line along the socket crease. Where the two lines meet at the outer corner, thicken the line and wing it up over the outer end of the brow bone. See the eye on the left. Blend these lines into the shape you can see on the right with a square-ended 1/4-inch (6mm) sable brush. Then add a line of color with the eye pencil underneath the lashes on the lower eyelid and blend it with the brush to meet the blended color on the top lid.

The color of the model's clothes will influence the color you choose for eye makeup. Generally, you should use neutral browns or blue-gray for color portraits because strong fashion colors date quickly and can look startling or overpowering in a portrait.

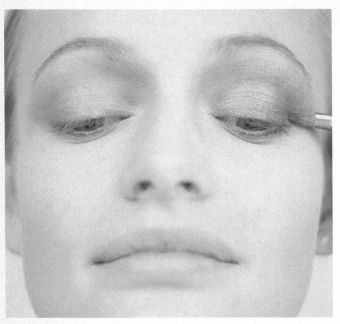

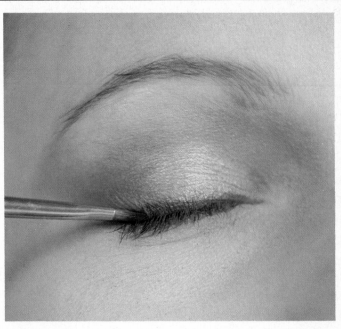

### 9) Eye Shadow
Brush over the penciled, blended pattern on the top lid with irridescent powder eye shadow of a color that tones in with the pencil. Use a 1/4-inch (6mm) brush for this, concentrating most of the color on the lid itself. See the eye on the right. Deepen the socket line and the outer corner with a darker tone of matte powder shadow, using the same color to intensify the line under the lower lashes.

### 10) Eye Liner
With a fine pointed brush, draw a line using dark powder shadow or eyeliner along the edge of the top lid, as close as possible to the roots of the lashes. Extend the line slightly beyond the outer corner of the eye and soften it a bit with a clean brush.

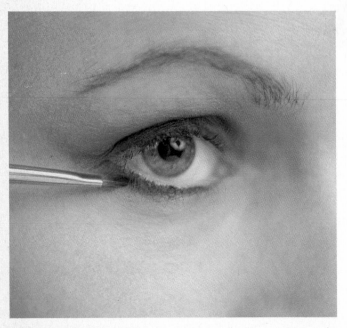

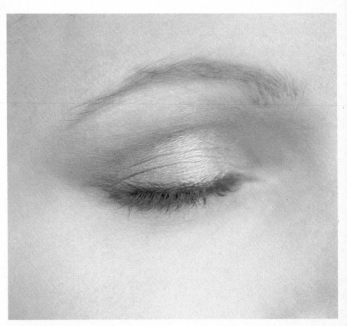

### 11) Lining the Lower Lid
With the same color eye liner, draw a very fine line along the edge of the lower lid, extending it at the outer corner to join the line on the top lid. Add a little extra color where the lines meet to deepen the shadow at the outer edge of the eye.

### 12) Highlighting the Eyes
Apply a highlight to the central area of the top lid with a light irridescent powder eyeshadow. With the same powder highlight, brush lightly along the center of the browbone immediately below the eyebrow to give it a slight shine.

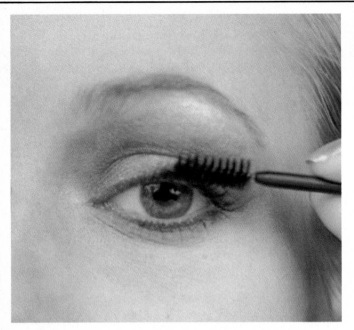

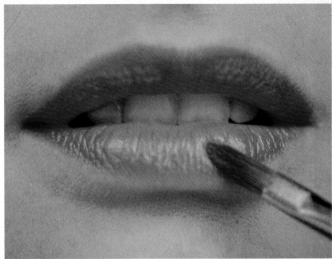

### 13) Mascara

Apply mascara generously. First do the bottom lashes and then the top so there is no risk of smudging the top lashes as you do the lower ones. Be sure the color is carried down to the roots of the lashes, giving them a couple of coats if necessary. Also, make sure the lashes are separated as much as possible.

### 14) Lips

With a lip brush, outline the lips with the chosen color of lipstick or gloss, widening a narrow mouth or making full lips narrower as you feel necessary. A sable brush was used here. Note that the model's lips were slightly *underpainted* because they might appear too large in proportion to the rest of her face.

Then fill in the center of the lips with the same color. If the lips are very narrow, paint the outline again with a deeper shade of lipstick and fill in the center with a lighter shade. This makes the lips look fuller.

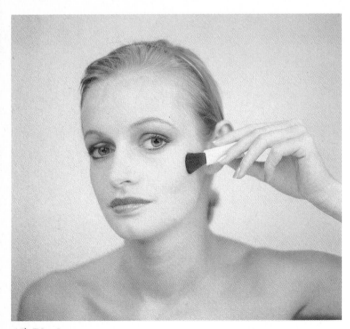

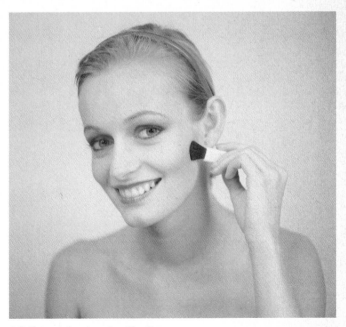

### 15) Blusher

Using a rouge brush, dust a soft application of blusher, chosen to tone in with the lip color, over the cheekbones. For b&w, omit this step because the red tones will reproduce as gray. The blusher then tends to flatten the cheekbones. Instead, add a touch of powder highlighter to the cheeks.

### 16) Strengthening the Shading

With the rouge brush and powder shader, strengthen the shadow under the cheekbones. If you have a slight double chin, you can also use this shader to make it less obvious. Apply it lightly under the jawbone and down the throat, making sure there are no obvious lines of dark color on the basic foundation color.

# The Seated Model

A fraction of a second of a person's life is captured in a photograph. It shows only a tiny instant of reality, but fixes it for a long time, in great detail. This is why it is often necessary to pose your subject for best results.

When you are with an individual, his or her gestures and movements over a period of time give a *cumulative* impression of the way that person looks. In a photograph, this has to be conveyed with one pose and expression. Also, in person, you tend to focus attention on one particular part of the individual—usually the eyes. In a photograph, you have time to notice the overall effect, including an awkward position of the legs or tightly clenched hands.

A professional model knows how to maintain a relaxed appearance. If you ask her to throw her head back and laugh for a pose, she can do it and then return to the original position for the next shot. With inexperienced sitters, make the pose as straightforward as possible.

## IN THE BEGINNING

Provide a comfortable chair—not too high or low, or with unwieldy arms—and ask your model to sit naturally. Study the image in the viewfinder and suggest ways to improve it. Use different poses. They are infinitely variable.

The secret of being able to tell a good pose from a bad one is to concentrate on the image in the viewfinder *as a picture*. A broad smile that captivates your attention when you make the exposure will not make up for the fact that the model's neck looks unnaturally twisted and awkward in the final image. This is *your* job, not the subject's. Be gentle, yet firm when directing her to change positions. You don't want to make her nervous by making her feel she is not doing things right. Let the model move and act as freely as possible. While she is doing this, you can decide what is the most suitable pose.

▼ Dancers and models know how to move gracefully and hold their bodies so they look good. Inexperienced subjects may need your guidance. Photo by Sanders.

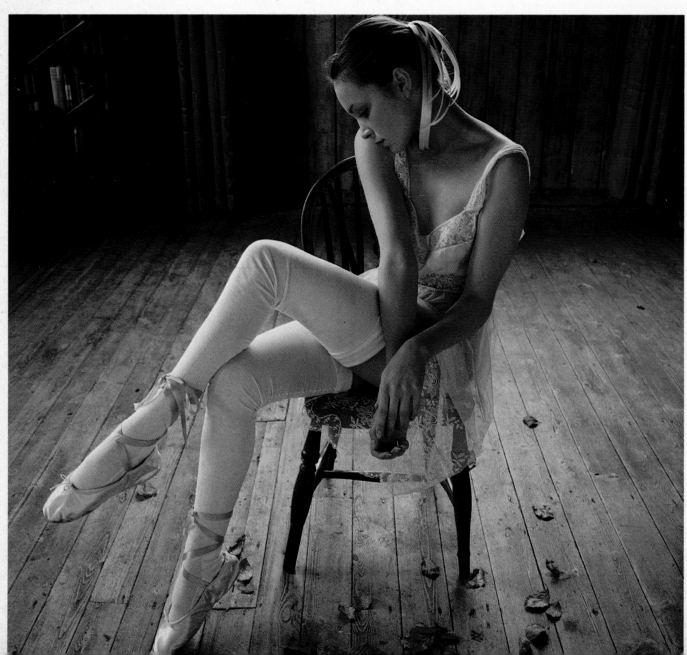

▲ Spread legs and fingers make the model look stiff and uncomfortable.

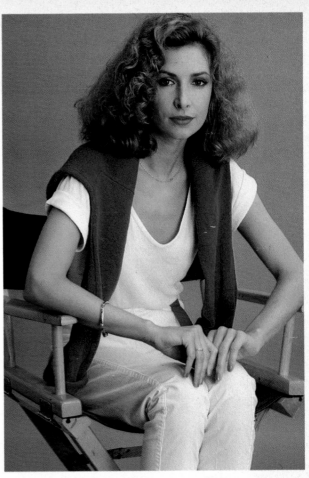

▲ The pose at left is improved with the model's knees together. Linking the hands creates a circle of the arms.

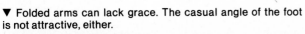

▼ Folded arms can lack grace. The casual angle of the foot is not attractive, either.

▼ By crossing the other leg, the model created a more pleasing line.

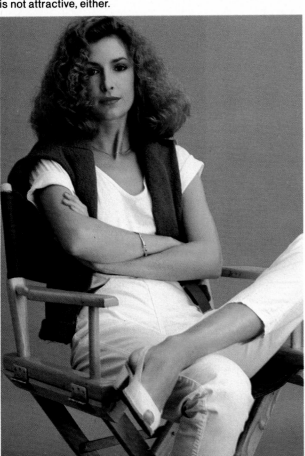

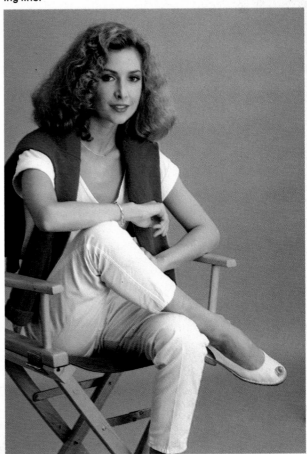

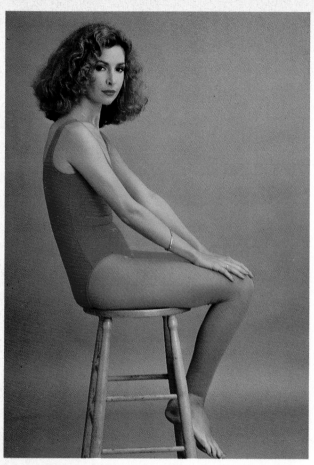

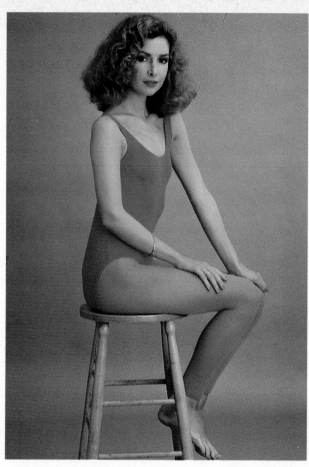

▲ A slouched back makes the subject look tired and accentuates the stomach.

▲ Sitting up straight solves this problem. A slight turn of the shoulders creates a better line.

▼ Even the shapeliest legs won't look their best if positioned like this.

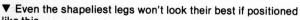

▼ By keeping her knees together and pointed slightly away from the camera, the model can show off her sleek calves.

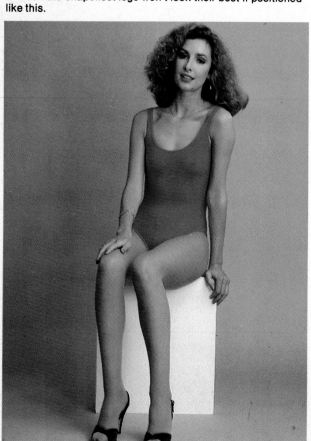

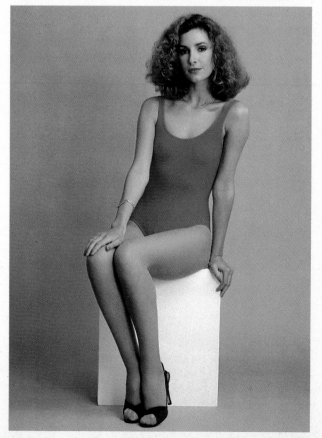

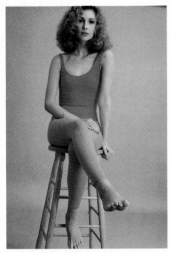

▲ Foreshortening makes the subject's thighs and toes look too big when they are pointed directly at the camera.

▲ Prevent foreshortening effects by keeping long limbs in the same vertical plane.

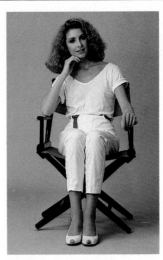

▲ This pose is good, but the subject is not relaxed. Her head is not really resting on her hand, and her legs don't look comfortable.

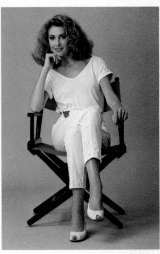

▲ A word of encouragement can give the subject the confidence to relax in a more comfortable position.

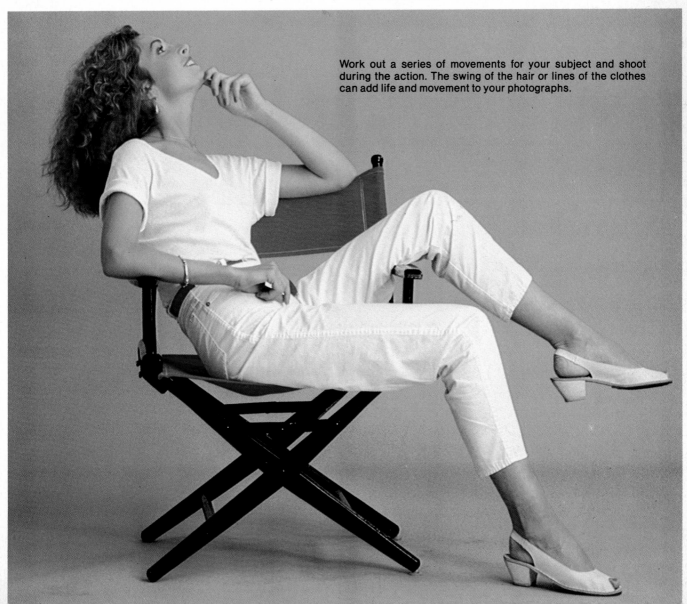

Work out a series of movements for your subject and shoot during the action. The swing of the hair or lines of the clothes can add life and movement to your photographs.

# A Guide to Posing

When you plan to take a posed picture of a woman, discuss with the model beforehand the kind of pose you want. If she knows what you want, she will usually be cooperative. Together, you should be able to find the right pose quickly.

Remember, too, that every woman is aware of her best features and will try to project them. She also knows which positions are comfortable for her and how to hold herself for comfort, poise and attractiveness. Let her become involved in the decisions. You can then fine-tune them as needed.

It is also important to consider the clothes your model is wearing. A leotard was chosen for these illustrations so you can clearly see the position of the model's limbs. Clothing can make a difference. You would not ask a model in a flowing evening dress to lie full length on the ground, for example, but you might ask her to do that if she were wearing jeans or a swim suit.

The most important factor in posing is to have the subject look relaxed and natural. If you try a couple of poses and these look awkward, allow her to move around freely until you see a pose through the viewfinder that you like. Then check each element of the pose to see how it fits into the overall image you want to produce.

Examine the position of fingers and hands, elbows, legs and feet. Be sure all are shown to their best advantage and are not distracting. Each limb should look "connected," with no parts of the body disturbing the *flow* of the figure. The posing guide on pages 55-59 illustrates specific problems you should be aware of, and shows how to correct them.

If the model is nervous, you can explain that some of the changes in position are necessary because of the optical effects of the lens, not because she looks peculiar in real life!

Subjects often will become nervous if you give posing instructions, but *you* are the one who can see the final result, so you are the one who must have the final say on the pose.

◀ Don't leave posing to the subject's discretion. She can make suggestions, but *you* should decide what works best. Photo by Hans Feurer.

▲ If the model turns her body slightly away from the camera while looking directly toward the lens, the visual effect is to slim the body. But it causes other problems. The subject's shoulder is too hunched, giving her back an unappealing curve. And her neck seems to have disappeared.

▲ The subject has straightened her shoulder and stretched out her neck. But, she now seems to be leaning back. Because of the angle of her body, she had to twist her neck too much to face the camera. This created deep creases.

▲ The crease in her neck disappears when she turns her body toward the camera. But here the angle of her head spoils the picture. When the model lifted the back of her head, she also tucked in her chin. Although she doesn't have a double chin, she appears to have one here!

▲ The model tilted her head differently so the double-chin effect disappeared. The shadows around the jaw line flatter her bone structure. She looks comfortable and natural.

▲ A question many subjects ask is, "What should I do with my hands?" This is one way *not* to hold them! When relatively close to the camera, the fingers look too big.

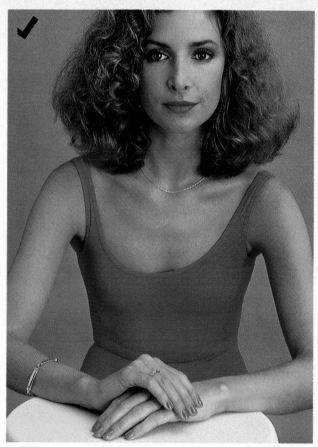

▲ This looks better. She should keep them together, with the nicer one, or the one with a decorative ring, on top.

▼ It can be attractive to have her hands near her face—but not this way. The fingers are obtrusive because they obscure the jawline.

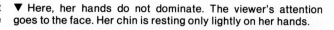

▼ Here, her hands do not dominate. The viewer's attention goes to the face. Her chin is resting only lightly on her hands.

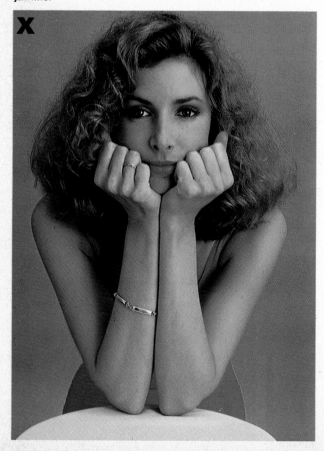

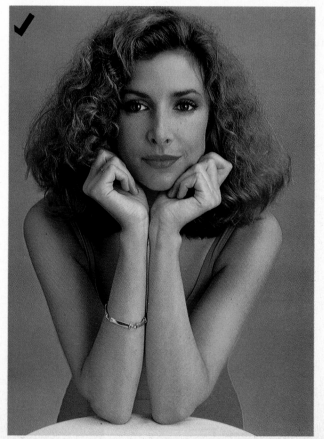

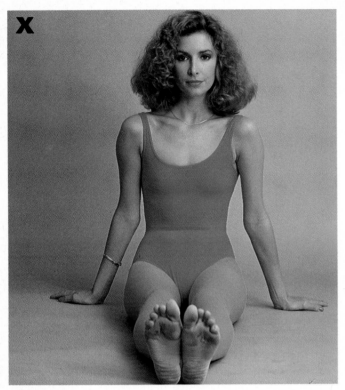

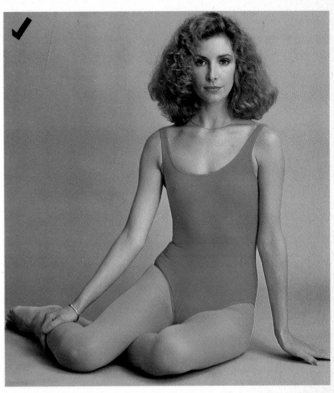

▲ Because of the effect of foreshortening, this photograph is dominated by a pair of apparently huge feet and short, stubby legs.

▲ By positioning her legs in nearly the same vertical plane, the subject appears more graceful. The foreshortening effect is eliminated.

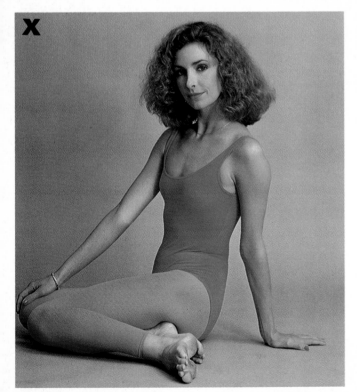

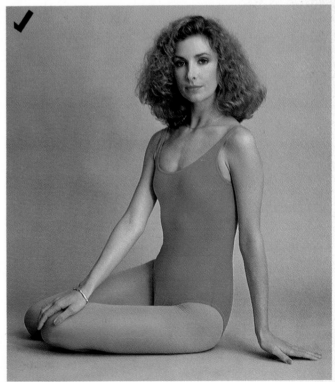

▲ When the subject is sitting with her legs to one side, be sure they point *away* from the camera. From this angle, the feet are distracting and distort her thigh.

▲ The clean lines and strong shape of this pose look much better. Her feet are hidden and do not attract the viewer's attention.

X

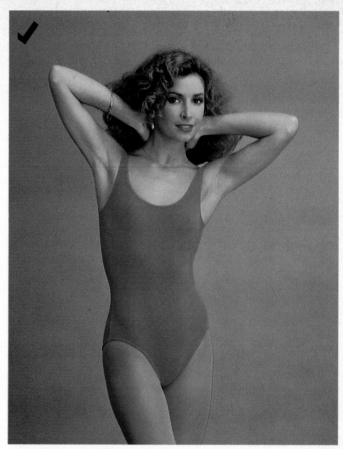

✓

▲ Another way to use the hands is to have the model brush them casually through her hair, for a feeling of movement. Here, however, her arms point toward the camera and appear distorted.

▲ Spreading the elbows outward puts the arms in better proportion because they are now on the same plane as the body. They also form a V-shape that frames the face.

▼ Be careful how hands are placed on the hip. Here, the subject appears to be suffering from a backache.

▼ By turning her hand the other way, the model looks more comfortable. Pointing her body toward the camera conceals the sharp curve of her back.

X

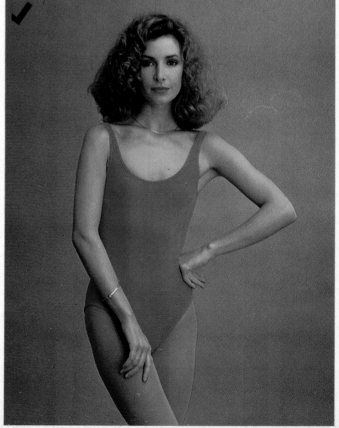

✓

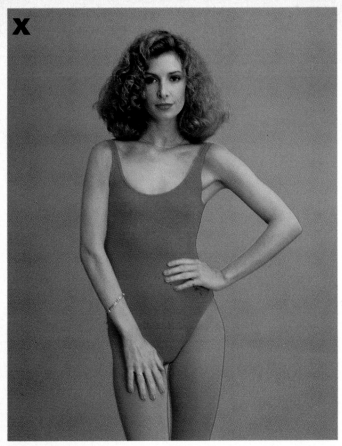

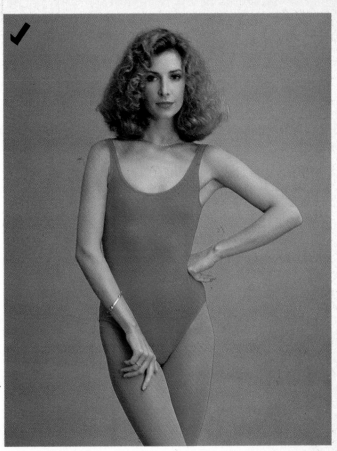

▲ Spreading the fingers on the waist is better than clutching at the small of the back. But with both hands spread, you see too many distracting fingers.

▲ This pose is better, not only because the hands are less obvious, but also because the subject has crossed one thigh over the other to improve the curve of her hips.

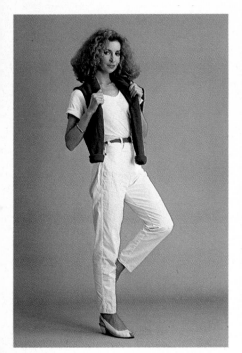

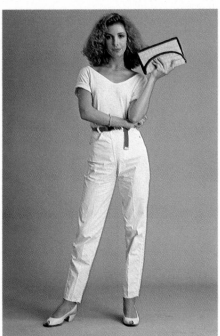

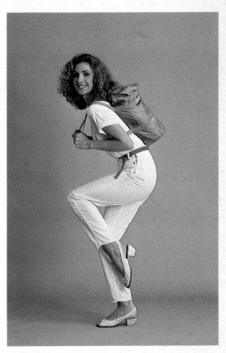

▲ The model's clothes can suggest ways to vary the pose and improve the picture. Something as simple as an extra piece of clothing can help. Nervous subjects are glad to have something familiar to hold on to while you are busy looking for a suitable pose.

▲ Different props suggest different poses. Let the model decide how to use the prop. Watch through the viewfinder until you see a good composition. If you don't see one, make suggestions.

▲ Props can often give you ideas for a *theme*. Slung on her back to look like a backpack, this bag suggested hiking to Tino Tedaldi's model and she assumed a suitable pose. Your subject may not be quite as versatile as this model, so help by letting her know when a pose works well.

# Fashion

Clothes play an important role in a portrait of a woman. She may be dressed up for an occasion, wearing an outfit for the first time or just showing off something homemade. The clothes may be the most important part of the photograph, or only one element in the composition. Clothing can tell a story, in a subtle or more direct way, and can also ruin a photograph if not presented properly.

Remember, in fashion photography, the model is *secondary*. She is there to complement the clothes, not the other way around.

Even if you don't want to make "fashion" photographs, you should still look at the pictures in fashion magazines. Note how the photographers create a certain mood and the feeling of movement. These examples will help you visualize scenes better and produce more interesting images.

One example of how a different effect can be achieved easily is to consider using a low camera angle when shooting fashion if you want the clothing to look more elegant. This angle takes the emphasis off the model and accentuates what she is wearing.

Fashion photographs can be made on location outdoors or in the studio. The combination of clothes, location, background and lighting sets the mood, or the mood may be set by the clothes alone.

Fashions change, and so do the settings that accompany them. For example, a period look, such as the 50s, might suggest props or backgrounds such as milk shakes, cola, rock-and-roll bands and dancers, or custom cars. A Japanese style might call for flat colors, fans, exotic flowers, bamboo and water gardens.

## FASHION OUTDOORS

Choose a location that contrasts with or complements the clothes. Try to find a location that provides a variety of backgrounds and props. A park or a patch of countryside is ideal. An empty stretch of beach is another possibility.

Avoid populated areas unless you intend to include other people in the photograph. Strangers will stare and may get in the way. This can disturb both you and the model. Because locations are real places, sometimes with wet grass and mud, you should warn your model of the risks and keep them in mind when shooting.

In general, work in the morning or afternoon with the sun at an angle and diffused

▶ The elements of this picture work together to show off the clothing. The flowers match the fabric colors, and the models look relaxed in the setting. Photo by Andreas Heumann.

▼ Stone and tweed contrast in tone and texture, and harmonize in color. In addition, the stitching and mortar lines work well together. The overall composition complements the elegant formal jacket. Photo by Julian Calder.

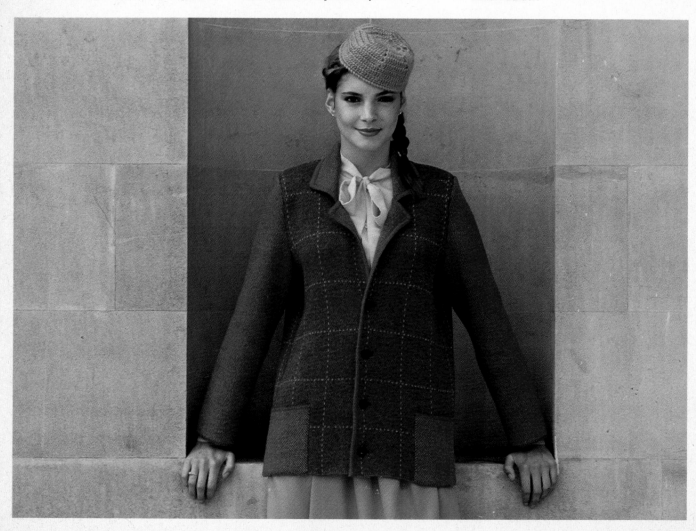

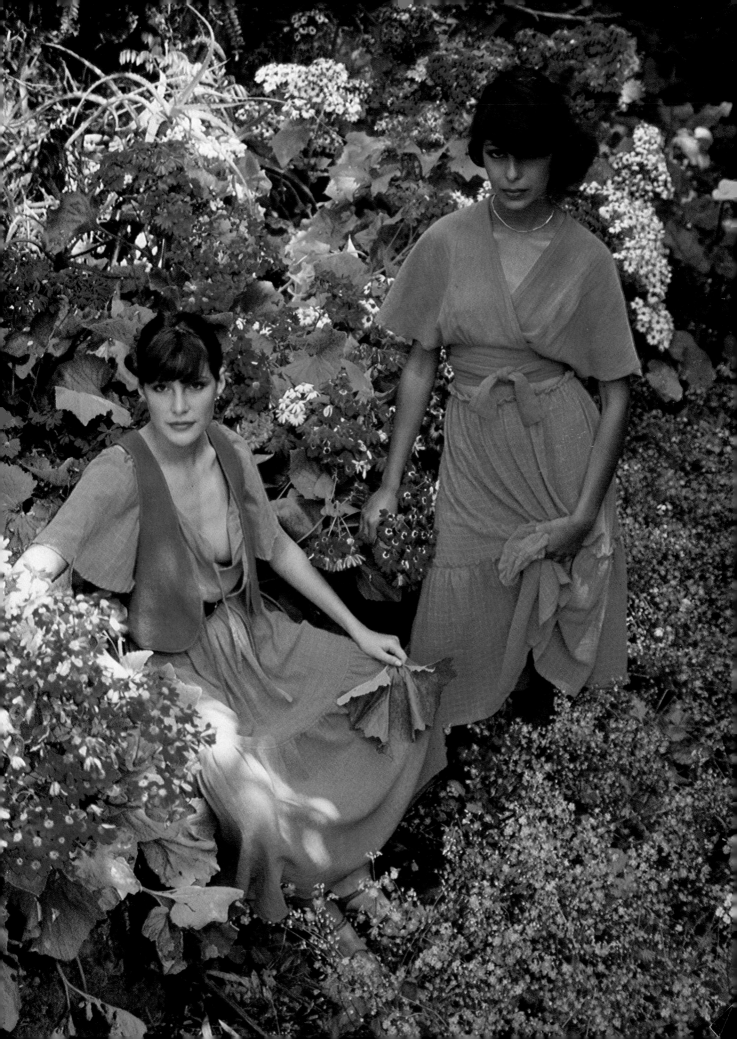

by clouds. Although the overhead lighting angle and dark facial shadows characteristic of midday sun are harder to control, they can also create interesting images. For example, a face in the deep shadow of a large hat will not detract from the garment, but will be a problem if you also want to show the model's face.

For the best overall lighting effect outdoors, work in the shade. Make your exposures when the direct sun is shielded by clouds if possible.

Another approach is to take advantage of back lighting. This adds interest to semi-translucent fabrics and creates a mysterious effect.

## SHOOTING INDOORS

Fashion photographs don't have to be made in a studio. You can use almost any well-lit room. All you need is a few props such as a chair, table and flowers to create the scene. Remember that the clothes are the most important element.

With no background, you have no scenery to help you compose or design the picture. Start with a high, front light and move it around to produce different moods. Try soft light and contrasty light, and experiment with the light source as a spot source, or colored by gels, filters or sheets of plastic placed over the flash.

Use a second flash to back light hair, eliminate background shadows or to produce more shadows. Shadows can be accentuated by moving the model closer to

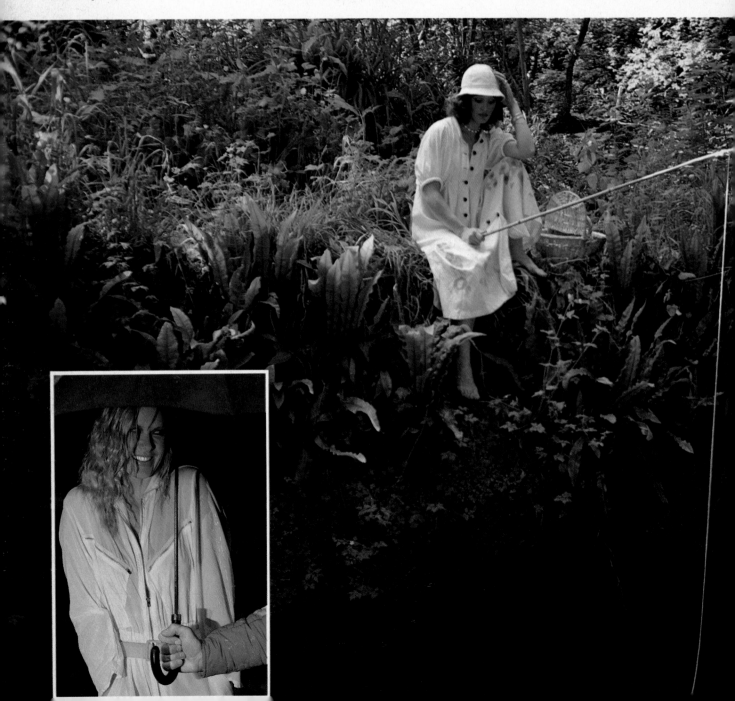

the background. A *ring flash*, a circular flash head mounted around the camera lens, creates a shadowless picture.

## MODELS AND MAKEUP

Consider someone tall and slim to model the clothes. People tend to look heavier in photographs than they actually are. However, you can photograph any physique. The type of model you use is really dictated by the results you wish to achieve. And, by using the proper

◄ The fishing pole and basket are believable props that also preoccupy the model. The model looks comfortable. The overall mood is one of a casual summer day. Photo by George Wright.

▲ The red sweatshirt looks vibrant against the black background and white pants. The model is using the towel to project a sense of movement. When photographing clothes, make sure colors do not conflict with the main subject. Use lighting that makes the clothes and model look good. One flash illuminates this model from the front with even light. Another flash from behind adds a few highlights. Photo by Tino Tedaldi.

◄ Inset: A look, a little water and a simple prop suggest a complete story. The picture comes alive. The lighting is from a single filtered flash. Photo by Tino Tedaldi.

makeup, clothing, camera angle and techniques as discussed in this book, you can make a heavier person look lighter or a bad complexion look clear, for example.

The model's makeup and hair also contribute to the mood of a picture. Makeup may be soft and natural or bright and brazen. Look in magazines for ideas. If the model is not an expert, try for a simple, natural look. Have her use a covering foundation, eye shadow, mascara and lipstick, as discussed on pages 44-49. Avoid shiny lipsticks and eye gloss unless you want this effect. They don't always look good in photographs.

Hair can be worn up, down, braided or crimped. Again, suit the style to the clothes and the desired effect.

## PICTURE SUGGESTIONS

A combination of clothes and location will help create ideas. First, have your subject move around so you can both get the "feel" of the outfit. Does it look best with the model standing, sitting, lying, running, jumping, laughing, looking sexy or aloof? Experiment with both complementary and contradictory poses. Think about the end use planned for the photographs.

Suggest some ideas to the model at the beginning of the session. A good model will be able to feel the part and project herself into it. But if you think the image looks wrong, don't be afraid to discuss it with her. Although you should not give the model too much direction, sometimes such guidance is necessary when the model must help make the clothes look good, rather than the other way around.

If you want action shots and have a good idea of what you want, tell her this, too. You may feel that the scene would look best if the model starts the action with her left foot, or leading with her left arm, for example.

You might suggest that the model look toward the camera or away from it. When working with more than one subject, if one of the models is looking toward the other, this can tell a completely different story than if they are not interacting.

◄ Little detail can be seen in either the hat or the jacket, but there is no mistaking the dramatic cut or the style of the outfit. This is what the viewer will remember. Photo by Sanders.

► John Garrett made good use of a simple background with a long focal-length lens. The steps become a geometric background that contrast with, and emphasize, the model's relaxed pose.

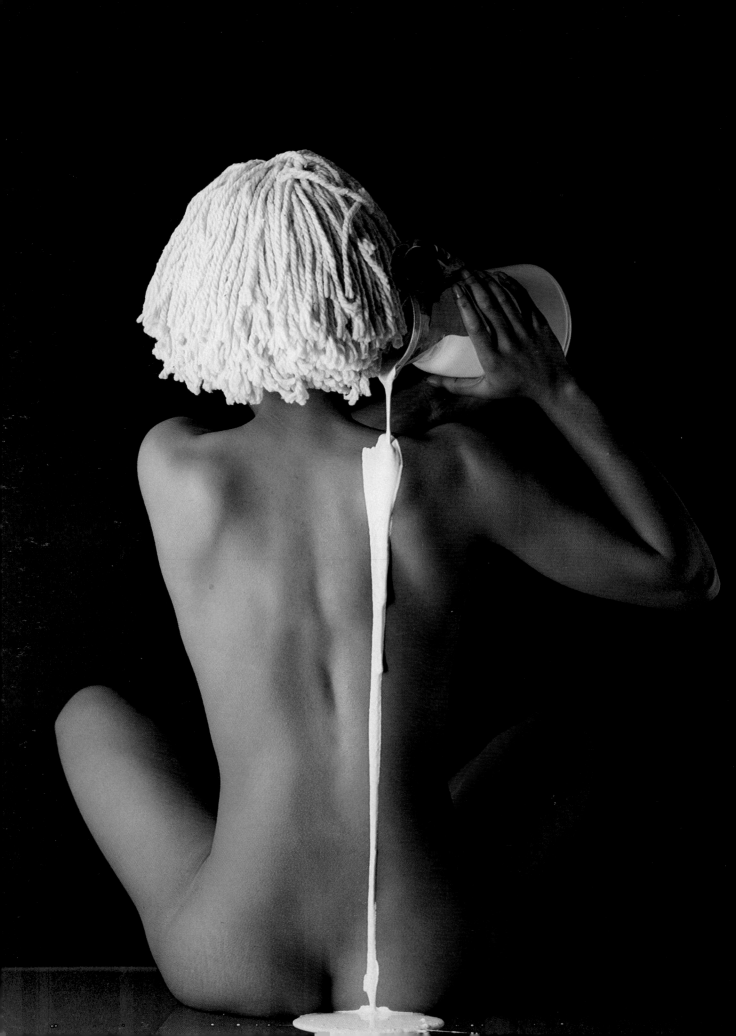

# Famous Photographers of Women

Earlier it was suggested that you look through magazines and books, and go to exhibitions to see samples of other photographers' work. Decide what you like and don't like in their styles. Then, when you do your own photography, you can start by working with the approaches that appeal to you.

In this section are portfolios from five famous photographers of women. Included with the photographs are interviews with these experts and comments about their background, experience and techniques. This will give you insight into how these individuals started and how they produce the photographs that have brought them international recognition.

Use the images displayed in these pages as a starting point for the development of your own style.

# Michael Boys

▲ Self-taught photographer Michael Boys began his career with a local newspaper. Now, he travels the world photographing women.

When Boys tired of that, he moved to London where he set himself up as a theatrical photographer on the basis of having taken pictures of local repertory productions in his spare time. Soon, more of his pictures were displayed outside theaters than any of his competitors.

The lucrative world of fashion and advertising photography beckoned, and by his mid-thirties, Michael Boys had his own business. His staff of 15 included other photographers, printers, retouchers, assistants, stylists and secretaries. He was undoubtedly successful—but he was also bored.

When he was asked to photograph the interior of a house, his career took yet another turn. "For some time I had been noticing the work of French photographer Fouli Elia who had been photographing interiors with a tremendous sense of style and excitement. His pictures portrayed the pleasure of living. At the time, architectural photography was dull and stereotyped—you simply set up a camera with a wide-angle lens in the corner of the room and made sure all the angles were right."

Boys produced *English Style*, a book packed with pictures of rooms vibrant with subtle color and warmth. It was to change his life.

After *English Style*, he became a photographer of international status. Despite his success, Boys inevitably began to consider possibilities other than photographing homes of the rich and famous.

One of the problems of being a photographer of women is finding outdoor locations where you can work undisturbed. Michael Boys once traveled to the Sahara desert to shoot pictures of models wearing topless swimming suits. When they took a break for lunch, he heard sounds coming from the other side of a sand dune. Creeping up the dune and peering over the top, he found another photographer also shooting pictures of women.

"It was not really as crazy a coincidence as it sounds," he explained. "Photography is a very small business, so photographers get to know the best locations for certain kinds of pictures. Thus, if you want desert dunes, there is this place not far from the road leading from Tunis into Algeria...."

Boys started taking pictures of women relatively recently. For many years he was best known for the warmth and glow he was able to inject into photographs of home interiors. He traveled the world photographing the homes of the rich and famous with such success that he became, in a modest way, rich and famous himself. Before that, he photographed parties and flower shows for a British newspaper.

He was born in 1930 in England. He became interested in photography while in school and saved enough money to buy a secondhand camera. He taught himself how to take pictures with an enthusiasm he neglected to show for his academic studies—Boys failed all his exams.

Not deterred by this minor setback, he got a job as a photographer for a local newspaper. From there, he joined a news agency where he learned the foot-in-the-door techniques of a more aggressive style of journalism.

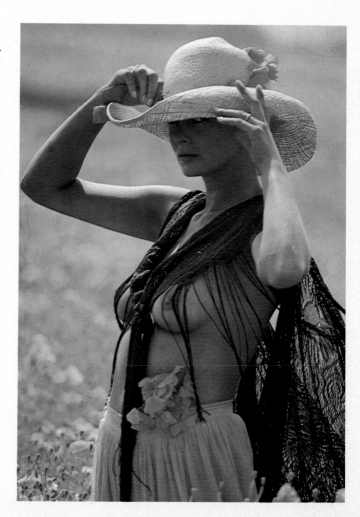

► This is one of Boys' amateur models. The hat covering her eyes helped her overcome her initial shyness.

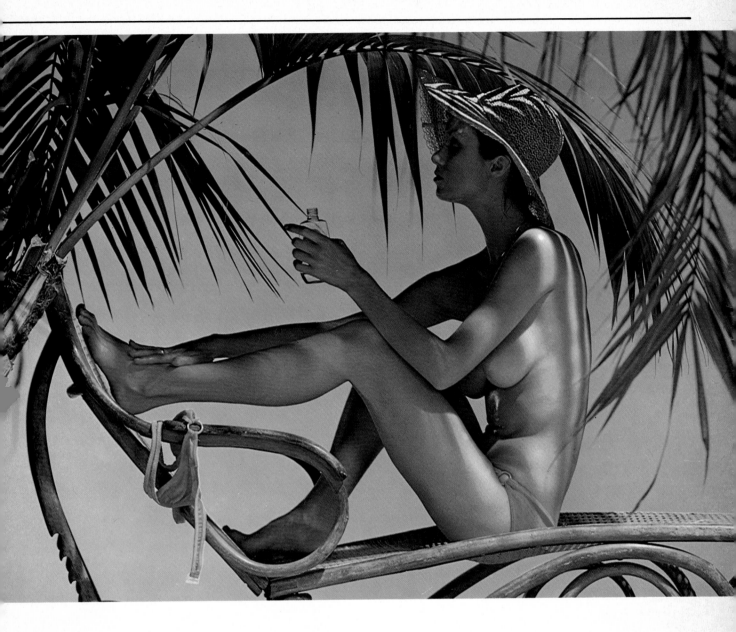

Photographs in Sam Haskins' book, *Cowboy Kate*, inspired him to start shooting for his own book of color photographs of women. He was forced to shelve the project but found there was an enthusiastic market for such pictures and became, almost by accident, a photographer of women.

"In fact, I was more than ready to make a move. There is a limited amount you can put into recording a domestic interior, no matter how sensitively. The attraction of photography of women, apart from the obvious one that it is more fun to do, is that you are taking a greater share of the creative action. You can find the model, clothe her or unclothe her, put her in a setting of your choosing, light her and direct her. It is much more *your* picture."

When possible, Boys prefers to work with women who have not modeled before. He finds them in shops, hotels and other public places. He is prepared to spend days teaching them how to help produce good photographs.

"It can be a struggle to get over the concept that a photograph has to be drawn and that arms, legs, breasts and bodies are the

▲ To give the effect of sunlight in the studio, Boys used one light source, mounted high above the model.

lines on the paper. I think it is worth all the effort. The problem with using models who have worked too much is that all they can offer is a catalog of glamour clichés. The picture reveals nothing that is of any interest to me. What I am trying to do with these pictures is mix qualities like surprise, charm and exuberance with a feeling of reality and believability. Eroticism does not come into it, nor does the glamour photography of the tabloid newspapers that turns the subjects into predictable nothingnesses."

Boys generally uses Nikon cameras, although he has also used a Bronica ETR-S, with a 4.5x6cm image size. This offers almost four times the film area of 35mm. He prefers to keep accessory equipment to a minimum because he travels a lot.

**Russell Miller**

► Shooting a calendar for a concrete company, Boys had posed a model on the top of this cement mixer parked behind his studio. Because it was a cool September morning, he warmed the top of the mixer with an electric blanket before the model posed. As he was starting to work, the milkman drove up. To provide some privacy, Boys gave the model a photographic umbrella and immediately saw the pictorial possibilities. This combination of the unexpected and the whimsical gives his pictures a special quality. He used a polarizing filter to intensify the blue sky.

▼ Boys was fascinated by the beautiful quality of this model's skin. The rings were hers. He added the lace and made a picture that has become his personal favorite. He used a 105mm lens, and lit the hands with one flash bounced from an umbrella.

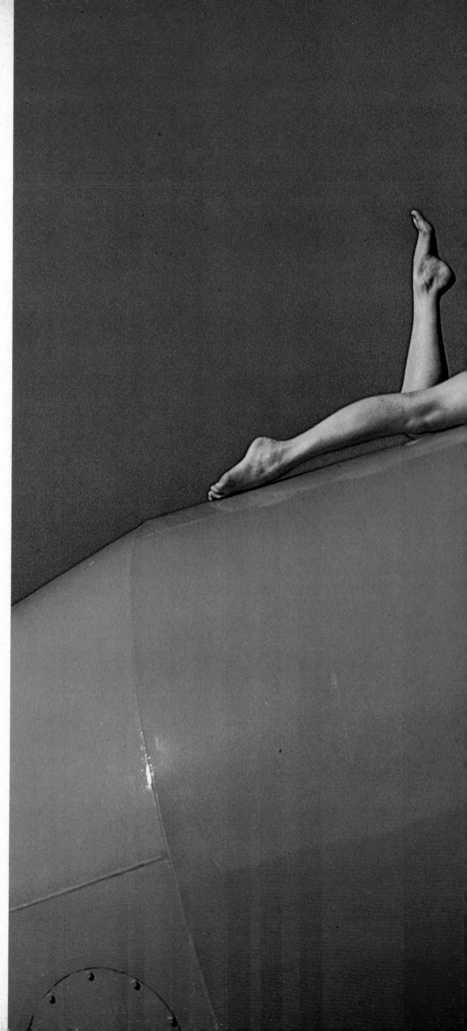

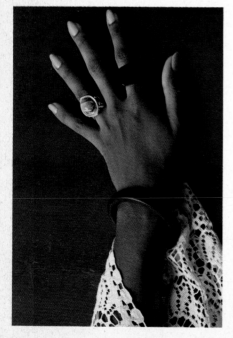

# John Kelly

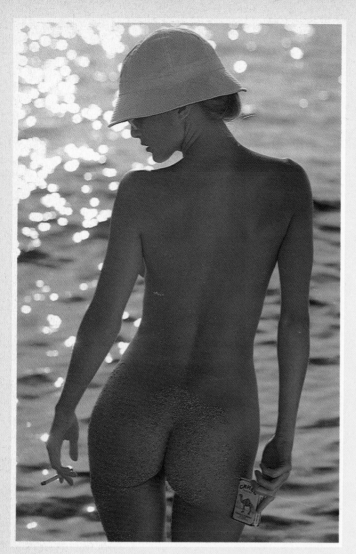

◄ This photograph was taken for a calendar. The cigarette pack and the model's back are lit by the evening sun reflected from the beach.

Slides of young women wearing little, if anything at all, cover John Kelly's studio lightbox. Kelly is searching from slide to slide while explaining the problems of shooting in sunny locations. "The key to these pictures," he says, "is finding the right model."

In one, the model is using an exercise machine. "I had the exerciser for another session and planned to use it for a shot like this. It's a good reason for her to be nude in that position. It's nice to be able to make all the things in a picture work together."

Katrina reclines in a Russian room set built in Paris. She is lit by tungsten and daylight. "I like to mix light sources. There's no substitute for daylight in this kind of work—if you can get it right—but sometimes tungsten adds a bit of sparkle." To suggest the tone he wanted in the pictures, he said "Anna Karenina" and "haughty but naughty" to her—and the whole session went easily. "She knew her way around," Kelly added.

The color and excitement on the lightbox is far removed from the exhibition that Kelly tucked under his arm and took to *The Sunday Times Magazine* in the 1960s. It was a collection of b&w photographs of slum clearance in Blackpool. Some prints measured 3x5' (1x1.5m) or more. "I was attending art college in the town and I wanted to be a Cartier-Bresson-like figure. *The Sunday Times Magazine* was everything I wanted, so I went there to make contacts. The people were responsive. The size of the prints staggered them more than anything else, and they said I should go around the corner to a magazine called *London Life*. That was a Friday. *London Life* wanted me to start on Monday. There were still nine months of the course to go at Blackpool, but the college said 'leave if you want,' so I left."

▶ Kelly went to Paris to make a photo in this prearranged set. Hairdressers, makeup artists and set designers were there to help with the session. The bright light behind the model is sunshine. A tungsten source near the camera provided the even foreground lighting. The tungsten source was filtered to balance the color of the tungsten light to daylight.

By the end of the decade, Kelly was doing freelance advertising work while supplying news and feature pictures to national newspapers. "I don't know how I started the work I do now. I can't remember. It was a transitional thing." Much of his work is speculative, kept in the glamour file that supplies stock shots for calendars. Kelly's girls have appeared in so many calendars that the Japanese call him "King of the Calendar."

He spends 10-15% of his time in a "dark and satanic" studio doing advertising work. It is equipped with an electronic flash and some battered tungsten lights that go on location with him.

"The flash is good and reliable. You can do most things in the studio with it. I'm doing a newspaper advertisement using a lighting approach that I've used for the past 10 years or so. It creates

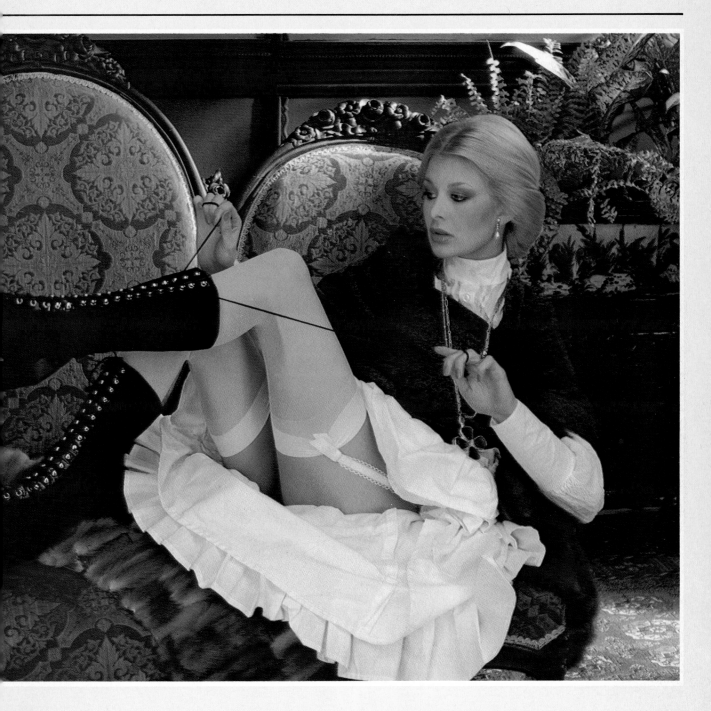

an endless white light—a good hard front light that gives plenty of edge definition. I put a couple of large, diffused flash units in front of the subject to create a light that seems like a hard flood or a soft spot. It's a distinctive light, giving good detail. But generally, I like shooting what I can see, so I use tungsten and daylight most.''

The battered tungsten lights have followed Kelly on location three or four times around the world. They go as insurance. They have been used only a couple of times as fill for shadows.

On an important assignment, he starts with ideas based on discussions with the client. He uses minimal equipment—a Nikon, 85mm and 35-70mm Nikkor lenses, and a 70-210mm Vivitar zoom—and carries a lot of Kodachrome and Ektachrome Profes-

sional film. ''If I've got the equipment, I use it. If not, I go ahead anyway.'' The sparse equipment and the sight of a worn Vivitar lens must give the clients a fright.

''Most of my work is done on location,'' he says. ''I'd rather dabble with the unknown than planned settings, although I like the idea of having sets built for specific things. I prefer to keep things simple. I have no assistant other than Gerry Barnes who acts as agent, manager, producer and, if necessary, someone to hold the reflectors.

''I like to solve my own problems. If one comes up, I depend a lot on my reporting and feature experience. You never know what kind of problems you'll find in that kind of work. I like working to deadlines and having the experience of not knowing

▶ The model is an amateur. The brightly colored props come from different sources. The cap is hers. The exercise machine, used at another session, was kept for an occasion like this. A polarizing filter darkened the sky, accentuating the white and yellow, and the model's tan.

▲ An advertising photograph of Vivien Neves, now Mrs. John Kelly, was the first full page nude to appear in *The Times*. This picture was taken at dusk in Portugal. Kelly visits Portugal two or three times a year to take photographs. He describes the evening light there as "fantastic."

what's going to happen next. I'd never have the patience to do the detailed work involved in still-life photography.''

A newsman's simple approach to photography frees Kelly to deal with the problems of choosing locations, selecting models and then getting the elements to work together. "Finding locations is not easy. It depends on who is sponsoring the trip. Magazines pay on publication—which may be six months away—so then I have to put up the money. If it's a calendar, the art director picks up the tab.

"Otherwise, I choose a location for what it has to offer. I've got a friend who can provide locations in Greece, Portugal, Jamaica and Palm Beach. Because Portugal has the most amazing evening light, I go there two or three times a year."

Kelly works with both professional and amateur models. He is happy with both, although the professionals know more about posing for the camera. Sometimes he chooses his models and sometimes the client sends models to him. "These models are all amateurs, literally off the street. We have a chat before shooting. I tell them what I want and we talk about the kind of clothes they like to wear. Sometimes a subject feels more relaxed in her own clothes, but dressing up can be a good thing because it gets her interested. It's all a lot of luck.

"I've had to change my style a bit working with them. They tend to exaggerate what they are—which is nice. But it is important to render them as sexy-looking women and not a particular look. After a few days, their personalities usually come out.

"If a subject is good, I let her do what she prefers. She knows more about herself than I do. But I don't want her to do things that she's done for someone else. I don't like talking to the models too much. I just start them off with some information on the kind of pictures wanted. If she's good enough, you can make her look sexy. If she's looking good, all that's needed is a nice drop of light, something alluring to wear, and 'click.'

"I like to deal with the woman's personality. It excites me, and that's the way magazines such as *Oui* and *Playboy* want the pictures. I like it when a subject sparkles. Some models have that ability and some don't.

"When everything else is right, the face is the next most important element. I feel that 90% of a woman's attractiveness is in her face. If the model has a blemish or scar, for example, you can change her pose to hide it. It's difficult to disguise a face, no matter how many makeup artists you have, because it is the face that helps you formulate her personality in the photograph."

**John Bell**

▲ The strong fill light shining into the model's face is reflected sunshine.

▶ Kelly made this exposure at a Barbados location he often uses for his stock file. He likes simple props.

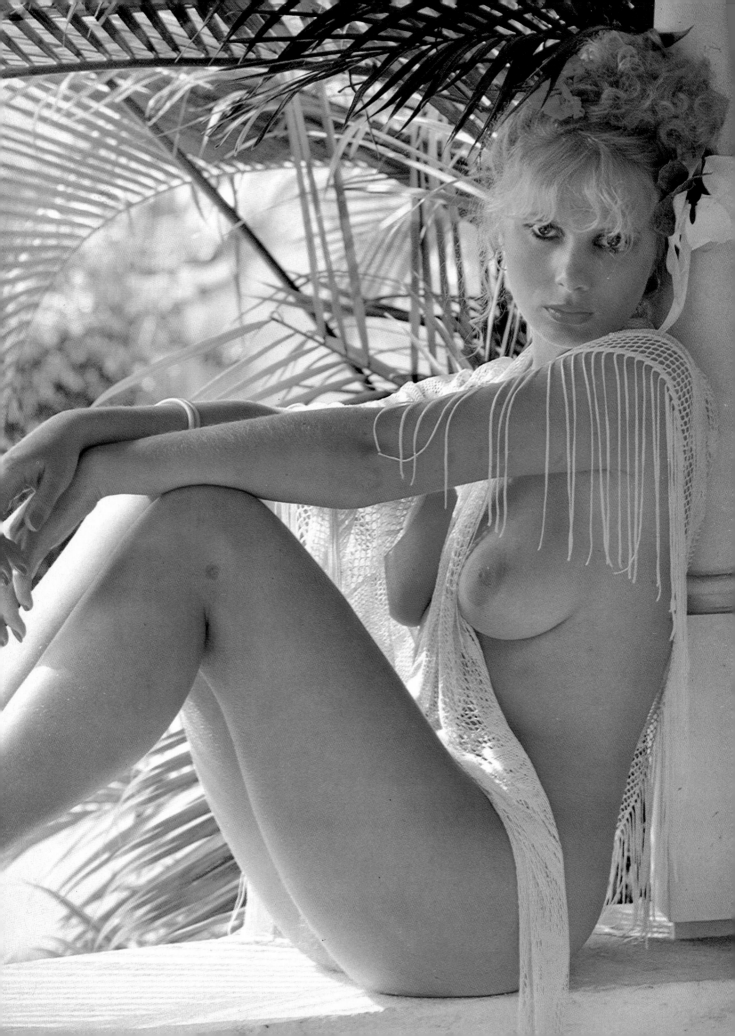

# Robert Farber

Unlike most of the new generation of professional photographers, Robert Farber had no formal training in his craft. Today he is one of New York's major fashion and glamour photographers. He learned about photography the hard way—on his own. It all began at a beach when he saw an enormous woman clad in a tiny bikini. "I wished I had a camera," he remembers.

At the time he was a student at the University of Miami, studying business and fine arts. Although his main interest was painting, he bought a camera and learned how to use it. Then he tried to get artistic effects by experimenting with diffused lighting, grainy film and filters. "I wanted to do things with photography that I couldn't do with a paintbrush," he recalls.

After college, he continued to experiment in his spare time and sold a few of his pictures. While working out of his home, he started to sell still-life and landscape photographs that looked painted. After a while, gallery directors sought out his work. Then he met advertising agency art directors who suggested he apply his talents to fashion photography.

A photography magazine printed some of his nudes and he received an assignment from *Viva* magazine. In 1973, Farber did his first big job for the Cotton Council—for a national advertisement showing a mother and daughter with colorful towels. The following year he rented part of a studio and soon his pictures were appearing in *Ladies Home Journal*, *Gentlemen's Quarterly*, *Playboy*, *Penthouse*, *Modern Bride*, *Esquire* and *Vogue*.

Farber does a lot of location photography abroad. An assignment for a catalog of spring fashions took him to Martinique—during winter, naturally. He flew there a few days in advance to scout locations and make Polaroid shots of the fashions. Then the rest of the entourage arrived—four models, an assistant, a stylist and the agency art director. An account executive, the person who runs the advertising campaign, was also there. They brought in a film crew, and Farber set up a composition similar to one of his photographs for a TV commercial.

Farber had been a professional for two years when his first book, *Images of Women*, appeared. In it, he bridged the gap between photography and painting with images that recall the work of the Dutch masters and the impressionists, and he explained how his special effects were created.

His next book was *Professional Fashion Photography*. Farber wrote about all the things he learned on his own—such as how to deal with clients, plan an assignment, put together an effective portfolio, and get a foot in the door at advertising agencies.

He uses motor-driven Nikon cameras and Nikkor lenses for his 35mm work. When he has plenty of time to shoot, or to deal with the details of lighting and composition, Farber removes the motor. "But when some of New York's most expensive models come to my studio, I have to work fast," he says.

His lenses range from 18mm to 500mm, but he usually uses the Nikkor 35mm, 50mm, 105mm and 80-200mm zoom. For commercial work, his film choice is Kodachrome 64, and for art work and books, Agfachrome 64 and 100. He pushes ASA 64 to 400 to produce a grainy effect, and uses filters and diffusion techniques to obtain the ethereal images that are the hallmark of his work.

His studio, in premises formerly occupied by a processing lab, consists of 3500 square feet (325 square meters), painted white. It includes a large dressing room, darkrooms for developing and printing, and two shooting areas—one for natural light and the other for artificial light. His staff includes a studio manager, two assistants, and an agent to handle business operations.

When he went to Jamaica for a client that advertises "jeans that fit as if they were painted on," he took a body-painting artist. It took three hours to apply makeup to the model, who was photographed in a three-quarters back view. During the bus trip from their hotel to the beach at Ocho Rios, the model was on her hands and knees to avoid messing her makeup.

After ten days back in New York, he had to return again to the same hotel and beach at Ocho Rios to do a job for the Jamaica Tourist Board!

Among the many beauty, glamour and fashion accounts he has handled, Farber has made advertising photographs for Revlon, Avon, Helena Rubinstein and many other big-budget advertisers. He has done campaigns for Caress soap, Monet jewelery and Toni hair products, In addition, he lectures to professional photographers in many cities, demonstrating his techniques.

*Moods*, another book he has done, includes a selection of landscapes, still lifes and nudes. The book describes his approach: "To achieve the image that corresponds with his original impulse, Farber uses the technology of photography fully. The final form of the picture depends on subtle manipulation of various types of film, film speeds, lenses, filters, filtering substances and exposures—all the techniques that comprise photography. If a mood is created by diffusion of light, that effect can be enhanced by filtering, by selective focusing or by pushing the film during development to break the emulsion. Illumination can be emphasized by overexposing certain areas, and dominant tones can be brought out by filtering or changing the type of film. However, all these techniques are secondary to merging the initial impression with the photographer's vision."

The key word is *vision*. Farber tells aspiring professionals: "Clients take your technical expertise for granted. They depend on your sense of design and your abiltiy to transform an idea into a picture. If you're talented and believe in yourself, don't give up. Keep going and you'll be successful."

**Harvey V. Fondiller**

▶ Farber planned all the elements in this picture to give the image drama and contrast. Electronic flash from one side leaves half of the face in shadow so it blends into the background. The flash highlights the texture of the model's skin, the lace cap and the red gloss of her lipstick. Farber kept color to a minimum, heightening the contrast between the black model and the white cap. It appears in his book, *Professional Fashion Photography*.

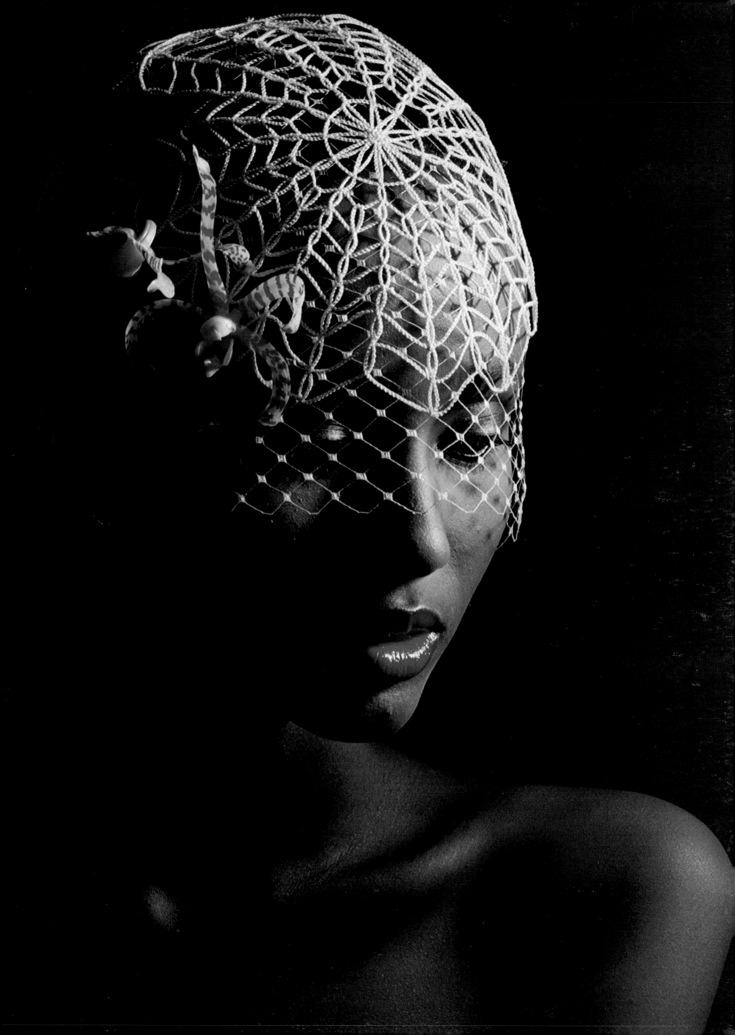

► This was a test shot produced to show some unusual jewelry. He lit the model with flash through an opal glass screen so the reflections in her eyes and in the earring would look like a window. The light was positioned so it would reflect in the metal circles showing the shape against the background.

▼ Here, Farber used a polarizing filter to cut reflections on the water and for more saturated color. Unless otherwise indicated, the photographs in this section were produced for use in Robert Farber's book, *The Fashion Photographer.*

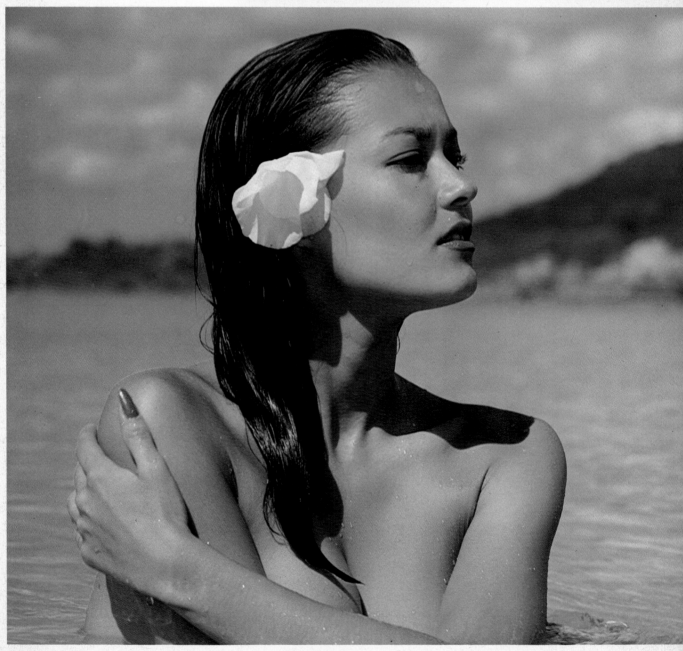

▶ This photograph of model Lynn Brooks was made with soft north light. Farber used a 400 ASA film, pushed to a speed of 1600. This increased the apparent graininess. He overexposed slightly to exaggerate the high-key light quality. For the diffused effect, he sprayed hair lacquer on a UV filter.

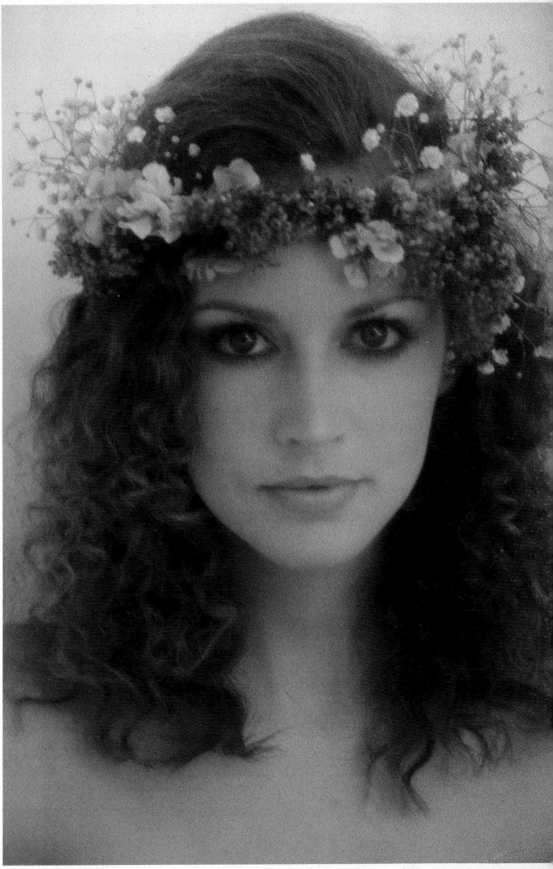

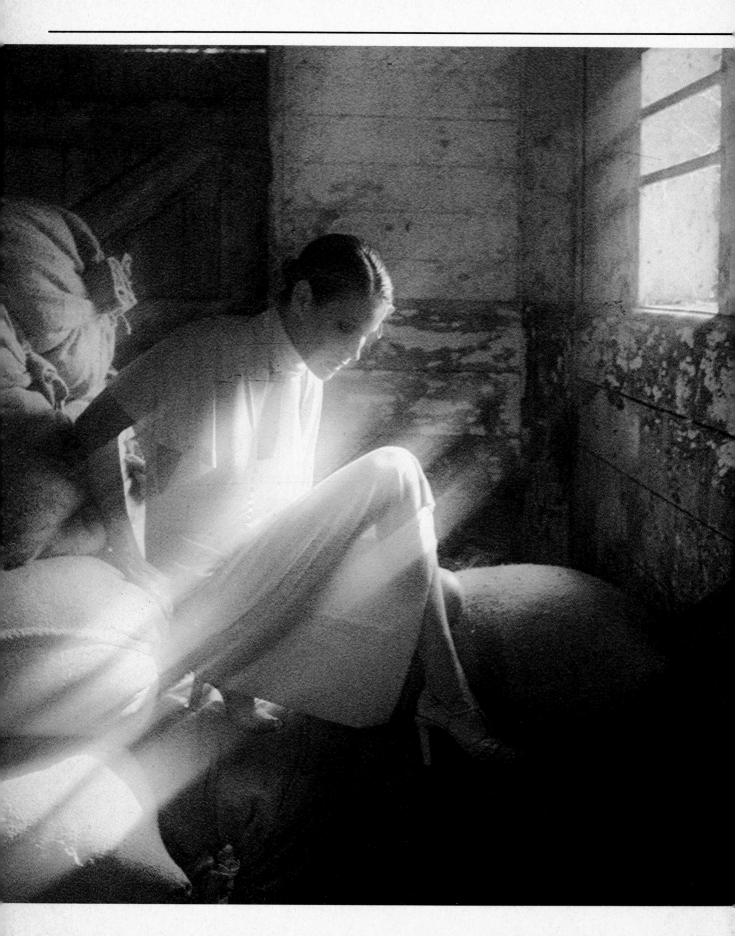

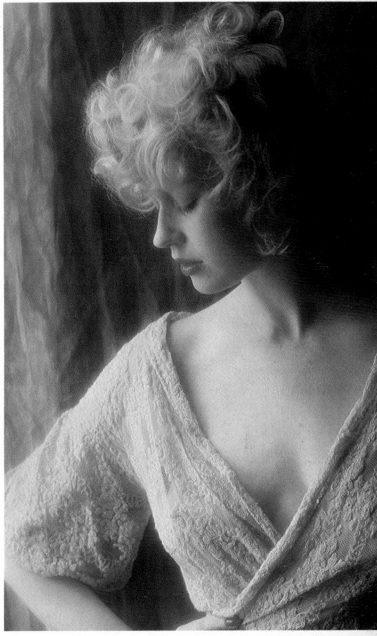

▲ Fashion photographs or beauty portraits are often improved by softening the image. Here, Farber used a soft-focus filter for the gentle, soft effect. You are drawn to the model's bright red lips. The rest of her makeup is pale, so the lips provide a focus of attention and a contrast against the muted colors of her clothes and surroundings. He used natural light in the studio. It appears in his book, *Professional Fashion Photography*.

◄ Lighting that complements the clothes is one of the most important elements in fashion photography. Here, Farber smeared a small amount of petroleum jelly diagonally across a skylight filter in the direction of the light rays to create the effect. He exposed for the shadows to record the detail, and allowed the highlights to burn out, giving these areas a bright quality. He push-processed the film to accentuate the grain.

# John Swannell

◀ Portrait of John Swannell by David Bailey.

▼ Swannell built this set by a window in his studio so he could use daylight coming in from the right side. For the soft-focus effect here, he used a Softar lens attachment on a Hasselblad 80mm lens.

John Swannell is a quiet, gentle man, and a prolific photographer. His large studio in north London is a beehive of activity as he is shooting a six-page fashion feature for *Vogue*. The telephone is constantly ringing, music plays in the background, and while the models are dressing, Swannell and his assistant prepare the set. That morning he was photographing on location 30 miles outside London and the afternoon session in the studio was expected to continue until 10 p.m.

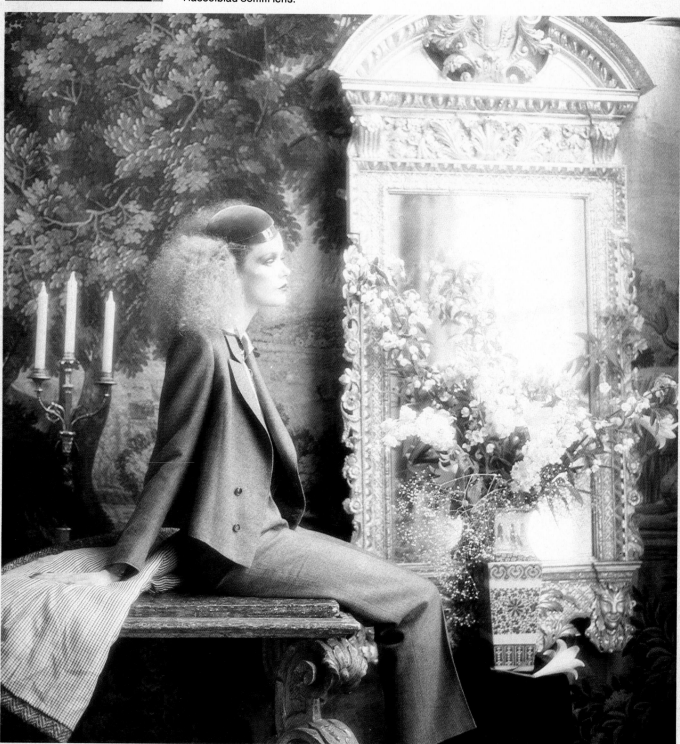

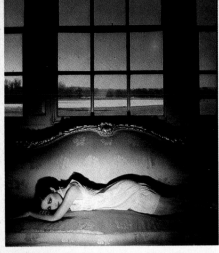

◄ This illustration for a feature on Victorian clothing was lit with daylight and flash. Swannell used a 35mm lens on an Olympus 35mm SLR.

▼ These models were lit by available light from a nearby window. Swannell chose the location, models, hairstyles, makeup and pose to suit the assignment.

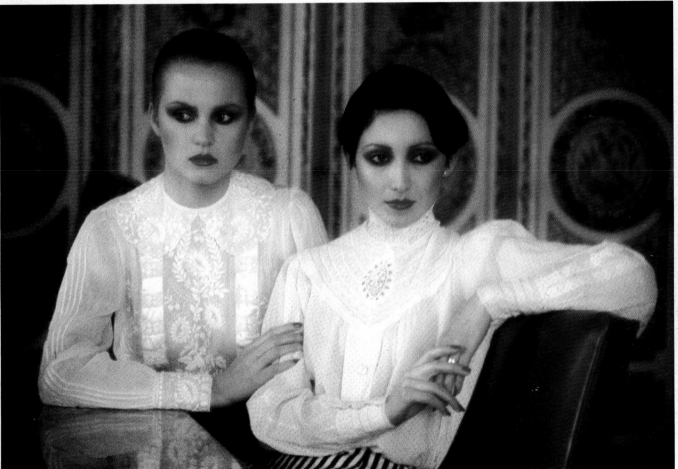

The client requested a curtain backdrop for the clothes but Swannell adapted this to a draped sheet of mottled gray canvas stapled in folds. His assistant stands in the model's position while Swannell positions the camera and checks exposure. Two flash units are positioned on either side and slightly in front of the camera, each fitted with a snoot to concentrate light. He always places one light solely for the face. The other light is set lower to light the clothes.

A 6x7 Pentax is his basic workhorse, although he uses an Olympus 35mm SLR for location work. He prefers the 6x7 format for studio sessions.

A glamorous blonde model glides down the stairs dressed in an elegant suit. From the front she looks the essence of smart chic. She turns and revels a line of pins pulling the costume tightly to her body. She stands in position against the backdrop and Swannell makes one Polaroid exposure, just to check everything. The

hairdresser combs through the girl's hair one last time. The fashion editor is happy and 10 minutes later Swannell has finished three rolls of film. The model changes position slightly after each click of the shutter. Swannell directs her to alter only the position of her face so shadows won't distort her features.

It all seems to happen so quickly. Swannell works by instinct. If the session doesn't "feel" right, he'll want to start again from scratch.

He decided to be a photographer when he was 12 years old. At 18, he got a foot in the door as supply room assistant at *Vogue* studios. One day, when a photographic assistant was ill, Swannell took his place. He never returned to the supply room. He became David Bailey's assistant and began to learn what fashion photography was all about. Bailey said that if he chose the most beautiful models, he was halfway there. He also stated that the only way to learn was by recognizing mistakes. It was what *not* to do that was

▶ Swannell uses a 135mm lens on his Pentax 6x7 medium-format camera for most of the fashion pictures taken in his studio. For the same size enlargement, image detail is better in a print made from a medium-format negative than from 35mm film.

When working outdoors, Swannell prefers the Olympus, with 35mm and 300mm lenses, and a medium zoom. However, the 35mm format doesn't produce the quality he wants in the studio. "Unless someone wants grainy pictures, I won't use a 35mm. Ideally, I'd like someone to make a versatile 8x10 twin-lens reflex and I'd use that!"

"For locations, I like big country mansions or modern architecture with strange windows and odd reflections." Windows, steps and lawns with strong lines and shapes form many of his backgrounds.

On an assignment in Israel, he persuaded the hotel manager to empty the swimming pool for him. "Everything about the hotel was ugly and made of concrete. The only good thing was the pool, which was large and graphic, but I wasn't shooting swim suits—I was doing evening gowns. The manager was a budding photographer and over dinner I persuaded him to empty the pool. The other guests were furious because no one could use the pool for 48 hours. It took 24 hours to empty and it hadn't quite emptied when I started to take the pictures. I had 10 minutes to shoot before they started filling it up again."

As in advertising, fashion pictures are also a team effort. Swannell employs freelance hair dressers, makeup artists and stylists to organize the clothes, accessories and props needed for the sets. Ideas evolve over a period of time, but the people he uses are familiar with his way of working. "My makeup artist knows I love pale, porcelain complexions with dark-ringed eyes. Someone always has to make the final decisions about everything—and that's me. I'm the only one who can tell if it's right in the viewfinder."

He dislikes using brightly-colored backgrounds because he finds they often distract from the clothes and the model. Neutral backgrounds and classic poses sound simple to achieve, but often take the most work. He prefers working in b&w, with Pan-X and Tri-X, processed in D-76. For color work, he uses Ektachrome 200 or 400, balanced for color with 81-series filters.

"I do all my own printing. It's very personal—you can't train someone to print your pictures, just as you can't train someone to take your pictures. There are always little things you see on the film that no one elso would spot." He always makes large prints. "Sometimes I do a little dodging in the printing to make the faces darker or lighter, but nothing drastic. If it's not on the negative, you haven't got it. Besides, a good photographer can always tell if you've tried to salvage a bad negative."

Besides fashion, he has done a series of portraits that began when he started working for a newspaper. He was commissioned to take pictures of other photographers at a convention in Cap D'Antibes in the South of France, and came back with a series of shots of Lartigue, an old master of photography. "I didn't ask him to pose or anything. I just watched him all the time—every move he made—and he was aware of it." He made his best exposures when his subject was walking down to the beach and suddenly sat down on the edge of the pier, crossing his arms over his legs.

▲ To photograph this model in a white dress against a white background, Swannell put black boards on either side of the model, just out of camera range. This darkens the edge of the dress, making it stand out from the white background. Two flashes lit the white background. The model was lit with a third flash bounced off a reflector.

important, such as avoiding shadows falling across the face. Eliminate the mistakes first and then just keep taking pictures—the more you take, the better you get.

Swannell can't remember why, but his single-minded attitude saw him through the next three years as an assistant. He is now a successful fashion photographer.

He prefers the Pentax 6x7 because of the rectangular format. "I was trained with Hasselblad cameras, but the square pictures always appeared in the magazines with a rectangular crop. So now I shoot rectangular pictures and crop the way I want." He generally uses 135mm and 200mm lenses with the Pentax.

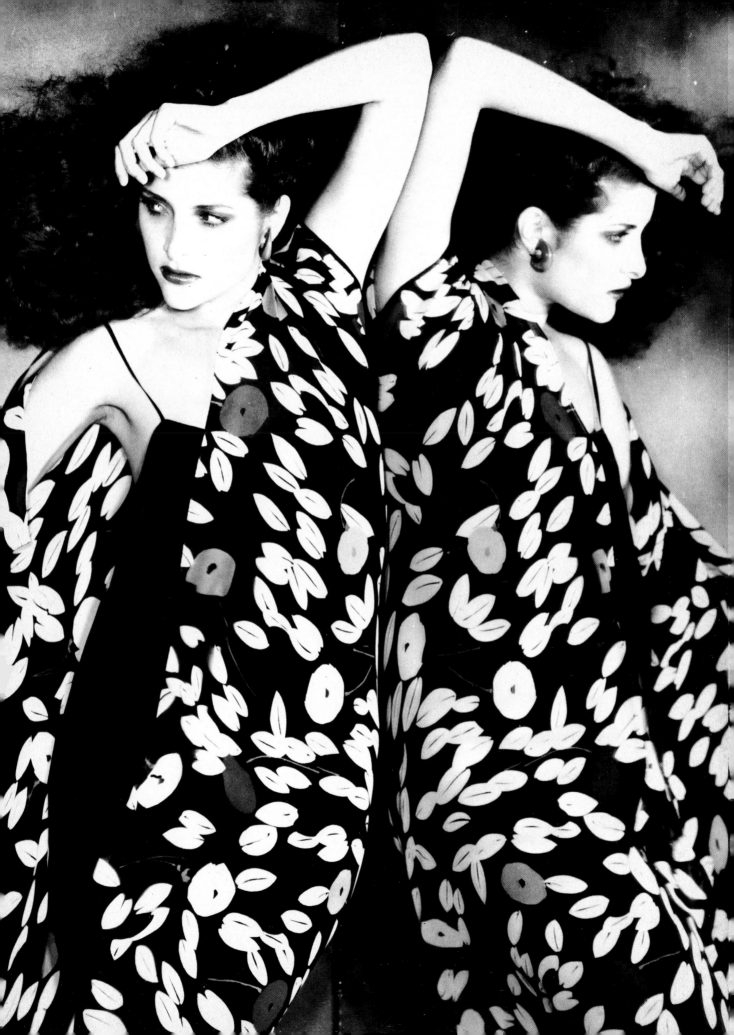

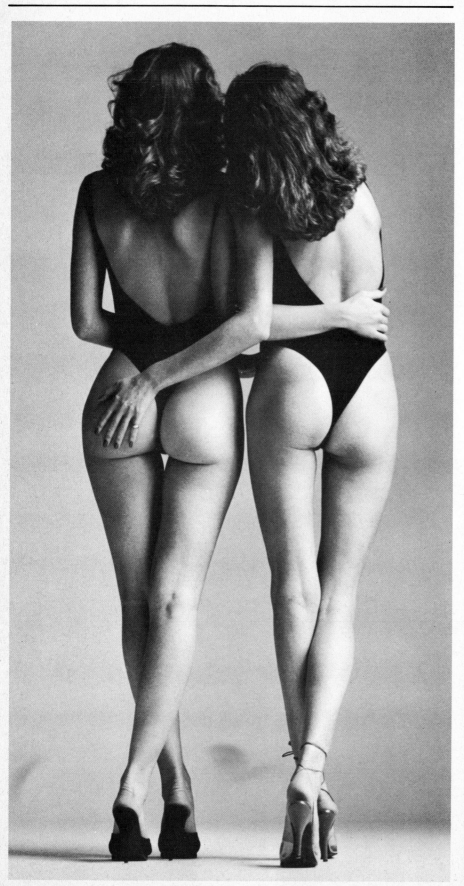

Swannell took the picture at left for a feature on swim suits. An art director saw the picture and altered it to make a strong advertisement for his client's hose, above. Swannell looked at 60 legs before selecting these models. The background was lit with one flash unit. The models were lit with two lights from behind and one in front. Black boards on either side of the models give the legs a dark line, making them stand out from the background.

Most photographers recognize the influence of others on their work. Swannell particularly admires the photographs of Irving Penn and Richard Avedon and, of course, David Bailey. But he has developed his own distinct style that is apparent in his choice of models, makeup, poses, lighting and backgrounds. Together, these give his pictures a timeless quality rare in these times of rapidly changing fashions and gimmicks.

The Italian fashion photographer Barbieri once told him to change some aspects of his work just a little bit every six months—"not too much, just a little. Take out a light or put one in. Over three or four years, your style will change quite a bit. You will be progressing and your style will never stagnate!"

Swannell loves women. He has a list of only four or five models he prefers to work with. He will use them as often as possible because they have a mutual respect and confidence that he thinks are essential for good results. He likes models who are elegant and work hard for the camera, listening and reacting to his instructions.

"Some women can sit on a chair six different ways—they're the good ones. They move around until they're comfortable. They watch the fold of the dress, and are aware of their arms and legs. They're natural, and while they're doing all that, somewhere along the line there's a picture. You see it, and tell them to hold it. It's a lovely feeling. It's one of the reasons I'll never get tired of doing fashion."

**Vivien Whiteley**

These two pictures were made for a lipstick advertisement. Swannell was asked to photograph the model against a light-colored background, but he also experimented with a dark one. He used a 200mm lens on a Pentax 6x7. One flash was bounced into a reflector, with other reflectors spaced around the subject to direct light onto the model's face.

▼ Swannell persuaded a model to stand in a fireplace to create this surreal image.

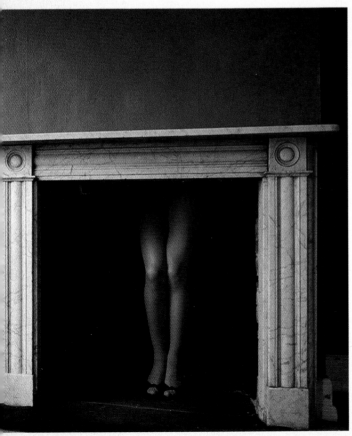

# Alan Kaplan

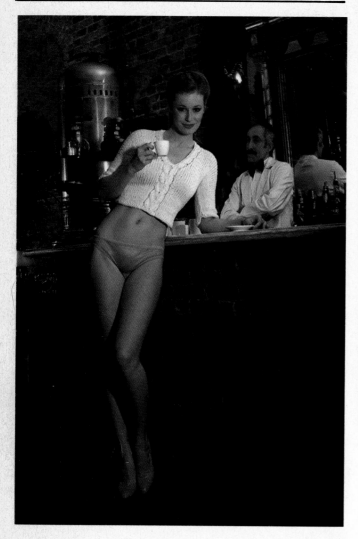

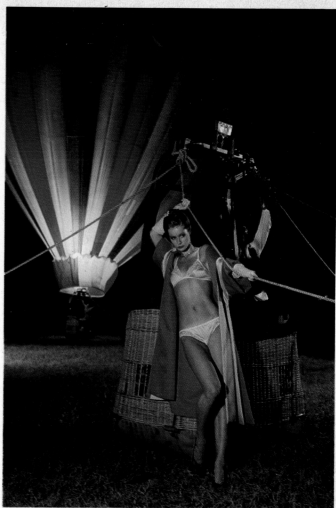

This series of photographs was made on location for a lingerie advertising campaign. Kaplan used electronic flash in different ways in each picture to create or balance the lighting so it would be appropriate for the individual settings.

Alan Kaplan has a calm manner and a pragmatic view of what he does, which is making photographs for some of the highest-budget advertising accounts in the United States. It wasn't always that way. Born in Brooklyn, he graduated from the School of Visual Arts and then, he recalls, "did as little as I could for three years—nothing for a living, but a lot of painting, mainly expressionist." Then he decided to make some money, so he opened a photographic studio. Though he still paints occasionally, he's kept busy most of the time with photographic assignments.

In 1980, for the second consecutive year, he was assigned to do a campaign for Maidenform. The multi-location shooting involved the use of many high-priced models and intricate logistics that presented major problems.

"My main job is solving problems," he says. "I work out an idea and make it physically possible to execute. The other part of my work is to make an esthetic contribution." After a briefing by advertising agency executives, the first step on the Maidenform assignment was done by professional finders, assistants and friends. Five people were involved in this task, which took three weeks. One of the requirements was a place to land a 60-foot sailboat. Other locations included a race track, an unoccupied Manhattan townhouse and a park where a model was photographed at a hotdog stand.

"The sailboat shot was an easy one," Kaplan remembers. "We balanced the light of the flash unit with the setting sun just before the sun dropped below the horizon." He shot 28 rolls of Kodachrome 64 in less than an hour and a half. The subjects were three female models wearing lingerie, with a man as a background figure. For this part of the assignment, Kaplan rented an air-conditioned bus with dressing rooms, a lavatory, and space for props and refreshments.

Kaplan was shooting fast with both hands on the camera while hanging off the side of the sailboat. An assistant helped support him. Another assistant loaded and unloaded the cameras. He also indexed the film, describing the photos made on each roll, so Kaplan knew what remained to be shot. A third helper, on a floating dock, made certain the subject-to-flash distance remained a constant 10 feet (3m). A fourth assistant handled the power lines from the dock to the Ascor QB-1000 flash unit. And another assistant was on security duty to make sure none of the equipment disappeared.

Three stylists supervised fitting the undergarments on the models and two others worked on hair and makeup. Among the observers were three people from the advertising agency—the president, art director and account executive—and two representatives of the lingerie company.

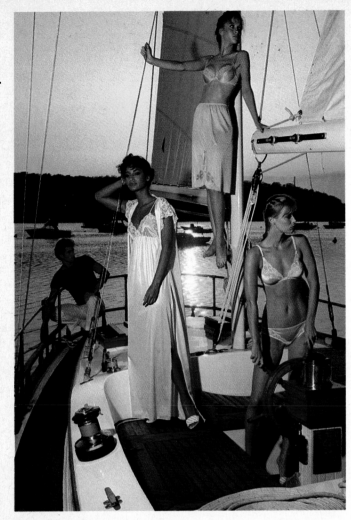

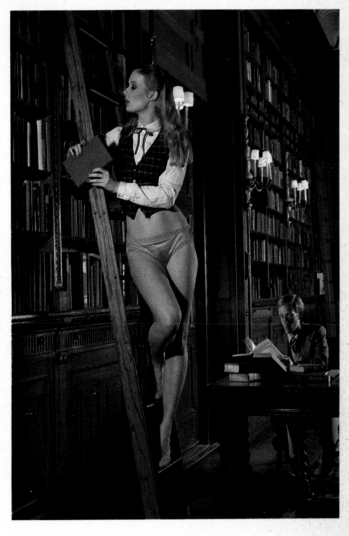

In the barroom scene, the flash was directed toward the model's torso, leaving her legs in shadow. For the balloon shot, Kaplan used a flash aimed at the model from the left and another farther back, lighting the balloon. On the sailboat, Kaplan shot into the sunset to get light on the water, and used flash to illuminate the subjects. He used straight flash for the library setting.

"Models work with their senses, and music is a form of support for them," says Kaplan. When on location, he takes a large portable recorder and tapes appropriate to the specific situation, much like the silent-movie era, when musicians played mood music on the set to enhance the actors' emotions.

Kaplan uses Canon and Leica camera systems. "My favorite bodies are the Leica IIIf, which was made in 1951, and the Canon A-1, which is about as electronic as you can get. Basically, I use a 35-70mm zoom lens and a motor drive so I can shoot at almost any distance and as fast as anyone can move. I can quickly change cropping and viewpoint."

He's so partial to the Leica IIIf that he owns 20 of them. "Leitz is running out of parts, so I cannibalize the ones I have," he explains. He also has six Canon A-1 bodies, two AE-1s, and several F-1s. He usually uses four cameras on an assignment.

Kaplan's studio occupies 5000 square feet in downtown Manhattan, just off Fifth Avenue. He also lives there. It saves "down time," he explains, referring to the hours that would be lost traveling if he lived elsewhere. The studio is equipped with a Cyclorama, a 7-foot (2m) light bank, cameras up to 8x10 and a dressing room. In the refrigerator, he keeps about 300 rolls of Panatomic-X b&w film and a few "bricks"—packages containing 20 rolls—of Kodachrome 64.

Kaplan, who has also made TV commercials and a short experimental film, says: "In New York, everything is time-keyed: Models are paid by the hour, assistants by the day. You're always watching the clock." To help cope with the complexity of his assignments, he keeps complete notes and diagrams of each session.

Internationally known in fashion and advertising photography, Kaplan goes to Europe several times a year. "I like to shoot for magazines because editors give me complete freedom," he says. On one occasion, the fashion editor of Italian *Vogue* "picked up a handful of lingerie, gave it to me, and told me to photograph it any way I wanted. From then on, everything was my choice—lighting, composition, interpretation."

According to Kaplan, to succeed in advertising photography, it is important to "research your photographs. Find out what you want to do and how to get there. Thorough preparation is as important as bringing film on location. The relationship of preparation time to shooting time is high. Sometimes it takes me only 20 minutes to make a shot that required a week to prepare for."

Kaplan attributes his success to "work—and a lot of it." Asked if an aspiring novice should attempt the leap to become a professional, he said, "If you like to take pictures, try it. You only live once!"

**Harvey V. Fondiller**

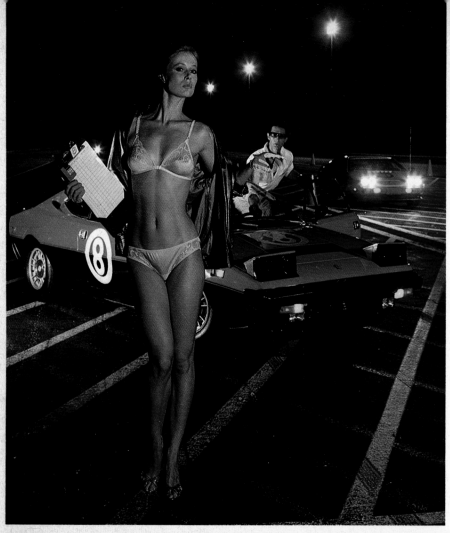

◄ For this photograph, Kaplan lit the model with flash from the right side. Another flash unit on the left, behind the model, illuminates the male model and the side of the car, accentuating the white number.

► For Italian *Vogue*, Kaplan posed model Pat Cleveland in a bizarre banana skirt in the manner of the famous singer Josephine Baker. The highlights on her gold shoes show that she was lit by flash from the front. He used a 35mm wide-angle lens with a pale orange filter to warm the skin tones.

▼ The location for this Italian *Vogue* assignment on beauty care was the photographer's room in a Milan hotel. The picture was exposed with ambient room light and a flash. Slight movement during the longer daylight exposure produced a slightly blurred outline around the subjects.

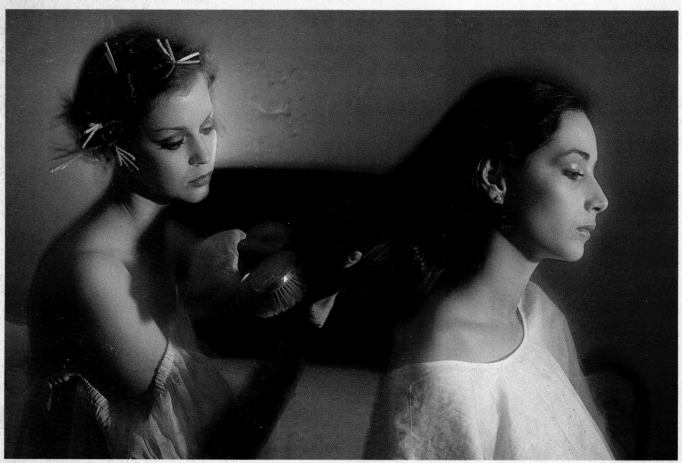

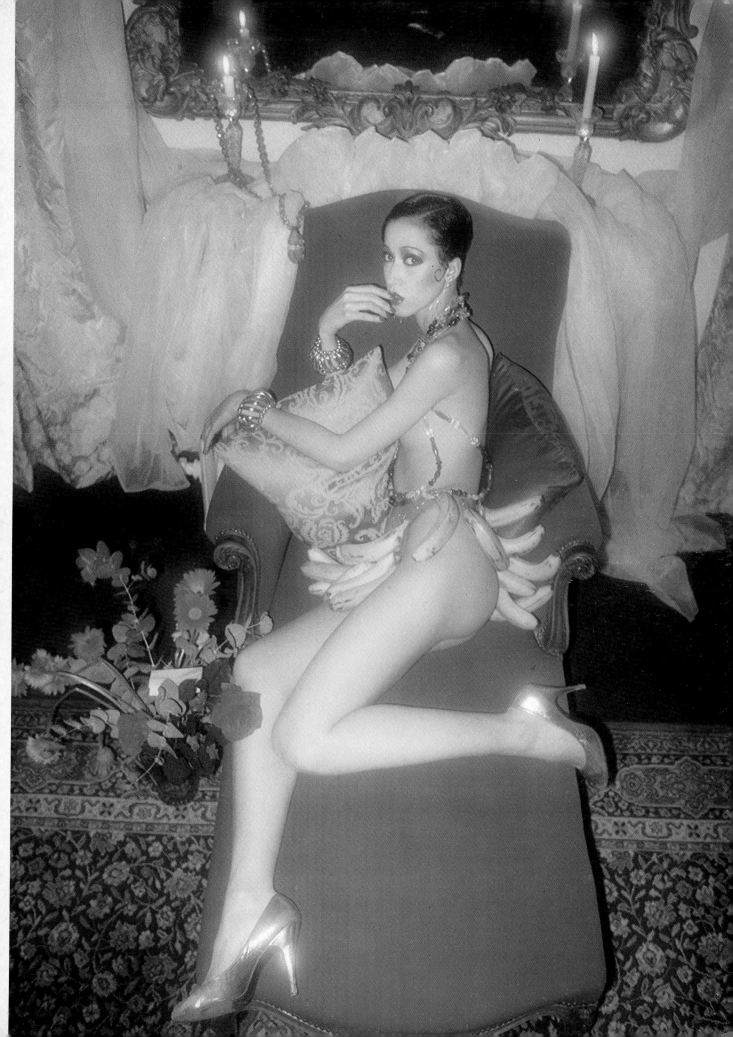

# Glossary

## A

**Afocal Lens:** A lens accessory that attaches to a camera lens to decrease the focal length.

**Angle of View:** The angle between the two rays that determine the diagonal of the film frame. Angle of view increases as focal length decreases.

**Aperture:** The adjustable opening in a lens that controls the brightness of the image exposing the film.

**Aperture Priority:** See *Automatic Exposure.*

**ASA:** An abbreviation for the *American Standards Association*, the organization that devised a film-speed rating for general-purpose films. As the ASA number doubles, film speed increases by one exposure step. Also see *DIN* and *ISO.*

**Automatic Exposure:** Camera metering system that sets shutter speed, lens aperture, or both after metering. There are three types: *Aperture priority* means you set aperture, camera sets shutter speed; *shutter priority* means you set shutter speed, camera sets lens aperture; *programmed* meters set both shutter speed and aperture.

**Autowinder:** Motorized unit that automatically advances film and cocks the camera shutter after exposure. This is an accessory with some cameras; built into others.

## B

**B (bulb) Setting:** The shutter remains open as long as the shutter button remains depressed.

**Barn Doors:** A lighting accessory used to restrict the light beam. Usually composed of three or four swinging doors.

**Bayonet Mount:** A quick-locking and quick-release fitting between the camera and lens or lens accessory.

**Bracketing:** Making a series of frames having different exposures. By making the metered exposure and frames with more and less exposure, you have a good chance of getting one picture that has "perfect" exposure. Bracketing is typically done in half- or full-step increments.

## C

**Catadioptric Lens:** See *Mirror Lens.*

**CC Filters:** Also called *color-compensating* filters, these are filters available in a variety of colors and densities. They are usually used for fine color control of color film exposure.

**Color Negative:** Film that yields reverse tonalities and colors after exposure and processing. Used to make color prints. Negative has an orange cast that does not appear in the print.

**Color Reversal:** Color film or paper that yields correct tonalities after exposure and processing. Also called *color positive.* Color reversal films and papers usually have the suffix *-chrome* in their name.

**Color Temperature:** A scale of values that represent the relative amounts of red, blue, and green light in a light source. Values are represented in degrees Kelvin (K), in which the higher the number, the bluer the light source. For example, midday daylight has a color temperature about 5500K. Candlelight, which looks much redder, has a color temperature about 1800K.

**Complementary Colors:** Yellow, magenta and cyan.

**Composition:** The arrangement of parts to form a unified whole.

**Conversion Filter:** Any colored filter designed to change the color temperature of the light to match the sensitivity of the film. Also called a *light-balancing* filter.

**Cool Colors:** Violets, blues and greens.

**Cropping:** Selecting the framing of the image. You do this when viewing a scene through the camera viewfinder. Some photographers also crop the image later during printing.

**Cyan:** A color formed by combining blue and green.

## D

**Daylight-Balanced Film:** Color film designed to give best color reproduction when exposed with 5500K light. See *Color Temperature.* Daylight-balanced film is available as color negative and reversal film.

**Depth of Field:** The distance between the nearest and farthest points of acceptable focus. Increase depth of field by decreasing image magnification, using small lens apertures, or both. Decrease depth of field by doing the opposite.

**Depth-of-Field Preview:** A control on the lens or camera that you use to manually stop down the lens aperture, allowing you to see depth of field through the viewfinder.

**Differential Focusing:** The technique of using large lens apertures, long-focal-length lenses, or both to create a narrow depth of field. This separates the focused subject from the out-of-focus foreground and background. Also called *Selective Focusing.*

**Diffuser:** Any material that scatters a beam of light.

**DIN:** An abbreviation for *Deutsche Industrie Normen,* a German organization that devised the European film-speed rating for general-purpose films. As the DIN number increases by 3, film speed increases by one exposure step. DIN and ASA speed ratings agree at a film speed of 12. Also see *ASA* and *ISO.*

## E

**Electronic Flash:** Light created by ionization of xenon gas due to rapid discharge of electrical energy. Color temperature of typical flashes is about 5500K. See *Color Temperature.*

**Enlargement:** Photographic print made from a negative or transparency that is larger than the original image.

**Exposure:** The amount of light that strikes a film—the product of illuminance and time. Exposure is determined by shutter speed and lens aperture.

**Exposure Meter:** See *Meter.*

## F

**False Attachment:** Compositional mistake that makes a background element appear to be connected to a foreground subject.

**Fast Film:** General classification of films with ASA speeds of 400 or higher. See *ASA.*

**Film Speed:** A numbering system that compares the relative sensitivity of films to light. As sensitivity increases, so does film speed. See *ASA, DIN, ISO.*

**Filter:** Any material that absorbs light. Filters can be made of glass, plastic or gelatin. They can be used over the camera lens or light source.

**Fisheye Lens:** An extreme wide-angle, small focal-length lens with an angle of view greater than 100°. A fisheye produces distorted images by curving lines that do not pass through the center of the image.

**Flare:** Unfocused, non-image forming light that exposes film. Typically, flare is from a bright light source shining toward the lens. It tends to expose shadow parts of the image, lowering image contrast.

**Flash Sync Speed:** Fastest camera shutter speed that works with electronic flash. With electronic flash and focal-plane shutter this is 1/125, 1/90, or most commonly, 1/60 second. With leaf shutters, electronic flash sync occurs at all shutter speeds.

**Floods:** See *Photofloods.*

**Focal Length:** Distance between the film plane and the *optical* center of a lens measured when the lens focuses rays from infinity to a point on the film plane.

**Focusing Screen:** Piece of plastic or glass that intercepts the image formed by the lens and reflected up by the mirror of an SLR camera. It is what you see when you look through the camera viewfinder.

**f-stops:** Series of numbers marked on lens aperture ring that represent the size of the lens aperture. Common *f*-stops are *f*-1.4, *f*-2, *f*-2.8, *f*-4, *f*-5.6, *f*-8, *f*-11 and *f*-16. Larger numbers represent smaller openings, and vice-versa. The exposure difference between *f*-stops in this series is one step.

## H

**Highlights:** Brightest areas of a subject or image. The opposite of shadow.

**Hot Shoe:** Flash holder on a camera that automatically connects to flash's circuitry when flash is attached. External sync cord is not necessary.

**Hue:** The basic color an object has.

**Hyperfocal Distance:** The near limit of depth of field when the lens distance scale is set to infinity. If the lens distance scale is set to the hyperfocal distance, the far limit of depth of field is infinity, and the near limit is half of the hyperfocal distance.

## I

**Interchangeable Lens:** A lens that detaches from the camera, allowing another interchangeable lens to be attached. See *Bayonet Mount.*

**Infrared:** Invisible part of the electromagnetic spectrum that has wavelength longer than that of red light. We sense it as heat.

**Incident-Light Reading:** A meter reading made by measuring light illuminating the scene. This is a method done with a hand-held accessory meter called an *incident-light meter.*

**ISO:** Abbreviation for *International Standards Organization,* which uses ASA and DIN speed ratings to indicate film speed; i.e. an ASA 100 (DIN 21) film is also rated ISO 100/21°. See *ASA* and *DIN.*

## L

**LED:** Abbreviation for *light emitting diode,* which is a small electronic device that glows. LEDs are used for exposure displays that are visible in camera viewfinders.

**Lens Hood:** A conical or rectangular tube of metal, plastic or rubber that attaches to the front of a lens. It blocks stray light from striking the front element of the lens. This preserves good image contrast.

**Light:** Visible part of the electromagnetic spectrum. It is the colors we see and photograph.

**Long-Focus-Lens:** A lens with a long focal length, typically greater than 150mm in 35mm photography. Also see *Telephoto Lens.*

## M

**Magenta:** A color formed by combining blue and red.

**Meter:** Device that measures light. It recommends camera settings for good exposure.

**Mirror Lens:** A lens that uses mirrors in addition to conventional lens elements to focus light rays.

## N

**Neutral-Density (ND) Filters:** Gray-colored filters that absorb light without changing its color balance. Used to reduce the light striking the film.

**Newton's Rings:** Multicolored lines created when two transparent surfaces make non-uniform contact with each other. Sometimes occurs with glass-mounted slides.

## P

**Pentaprism:** An optical device used in a camera viewfinder to make a laterally-reversed image read correctly from left to right.

**Perspective:** The relative sizes, shapes and distances of three-dimensional objects reproduced in two dimensions. In photography, you control perspective by camera location.

**Photoflood:** A photographic lamp using a tungsten filament. Yields 3200K or 3400K light.

**Polarized Light:** Light that vibrates in only one plane along its line of travel.

**Polarizing Filter:** A filter that absorbs polarized light. Used to accentuate colors or reduce reflections from materials other than unpainted metal.

**Primary Colors:** Blue, green and red.

**Push-Processing:** Extended development time of a film to compensate for underexposure. This essentially yields a "faster" film because you can expose the film at a higher-than-normal film speed. This technique is used with color and b&w film. Typically, film contrast increases and color balance may shift.

## R

**Reciprocity Law:** This law states that exposure is the product if illuminance (aperture) and time (shutter speed). For a certain exposure, a variety of shutter-speed and lens aperture combinations can be used of their "products" yield the same exposure.

**Reciprocity Law Failure:** This occurs when shutter speeds are very long or very short. Film appears underexposed even though the calculated exposure should give good results. When using general-purpose films, this occurs with speeds longer than 1/2 second or shorter than 1/10,000 second.

**Red Eye:** The phenomena of flash light reflecting from blood vessels in subject's eyes so the retinas reproduce bright red on color film. Happens only when flash is very close to lens-to-subject axis. Avoid the problem by having the subject look away slightly, or move the flash away from the lens-to-subject axis.

## Reflected Light Reading

**Reflected Light Reading:** A meter reading made by measuring light reflected from elements in the scene. This is the method used by most built-in camera meters.

**Reflector:** Any material that bounces light. Smooth silver or white materials reflect the most light without changing its color balance.

**Retrofocus Lenses:** Lenses designed with the optical center behind the rear lens element. This design makes interchangeable wide-angle lenses possible.

**Reversal Film:** Color film that yields correct tonalities after exposure and processing. Also called *color positive* or *slide film.* Color reversal films usually have the suffix *-chrome* in their name.

## S

**Saturation:** The purity of a color. Purest colors are spectral colors with 100% saturation.

**Selective Focus:** Using reduced depth of field to place the subject of interest in sharp focus with the rest of the scene out of focus.

**Shutter:** The camera mechanism that controls the duration of exposure.

**Shutter Priority:** See *Automatic Exposure.*

**Single-Lens Reflex (SLR):** Classification of cameras that use one lens for viewing and taking the picture. During viewing, a mirror reflects the image to the viewfinder. During exposure, the mirror moves out of the way of the image, which strikes film behind the open shutter.

**Skylight Filter:** A filter that absorbs ultraviolet (UV) radiation and some blue light, reducing the excessive blueness in color images. No exposure compensation is necessary.

**Slave Cell:** Device that senses flash light and almost instantly creates an electrical impulse to trigger another flash connected to it.

**Slide:** Image on film that has correct colors or tonalities. Used in projector for viewing an enlarged image. See *Color Reversal.*

**Slow Film:** General classification of films with ASA speeds of 64 or lower. See *ASA.*

**Snoot:** Lighting accessory that limits a beam of light to a small area.

**Spectrum:** The range of electromagnetic radiation organized by wavelength. The visible part of the spectrum (see *Light*) includes short blue wavelengths and long red wavelengths. Ultaviolet radiation is invisible and has wavelengths shorter than blue light. Infrared radiation is invisible and has wavelengths longer than red light.

**Standard Lens:** Lens with angle of view between 40° and 59°. With the 35mm format, this is a lens with a focal length between 45mm and 55mm. Many cameras are sold with a lens in this range.

**Stopping Down:** Selecting a smaller lens aperture (bigger *f-*number). Increases depth of field, cuts down light illuminating film.

## T

**Teleconverter:** Lens accessory that fits between the camera and lens to increase lens focal length, thereby increasing image magnification. A *2X teleconverter* doubles lens focal length. A *3X* triples it.

**Telephoto Lens:** A lens designed with its optical center toward the front of the lens. This allows interchanging various long-focal-length lenses on a camera body. This expression is also used to describe any lens with a focal length longer than standard. With 35mm photography, this includes lens focal lengths longer than 55mm.

**Tone:** The shade of a color. Most often used in b&w photography, when a neutral color, such as white, gray or black is described.

**Transparency:** An image with correct tonalities or colors on film. Used in a slide projector for enlarged viewing. Also called a *slide.* See *Color Reversal.*

**TTL:** Abbreviation for *through-the-lens* used when referring to a camera with a built-in meter that reads the light through the lens.

**Tungsten-Balanced Film:** Color film designed to give best color reproduction with 3200K or 3400K light. Also called *Tungsten Film.*

**Tungsten-Halogen Lamp:** Light source using a tungsten filament in a halogen gas. This type of bulb has a long life.

## U

**Ultraviolet Radiation (UV):** Invisible radiation that can expose film. Reproduces as blue with color film, as low-contrast haze in b&w. Most prevalent at high elevations or when you photograph distant scenes. Effect removed by using a UV filter. See *Spectrum.*

## V

**Variable Focal Length Lens:** Lens with more than one focal length. Change focal length by adjusting a ring that moves lens elements. Also called a *zoom lens*.

**Viewfinder:** Part of the camera you look through to see the image on the focusing screen. On most 35mm cameras, the viewfinder is a pentaprism that shows the focusing-screen image right side up and laterally correct.

**Viewpoint:** Location of camera relative to subject. Changing viewpoint changes *perspective*.

**Vignetting:** Image cutoff due to light rays being intercepted before they can expose film. Typically occurs in the corners of the image.

## W

**Warm Colors:** Yellow, reds and oranges.

**Wide-Angle Lens:** Classification of lenses with angles of view smaller than that of the standard lens. With the 35mm format, this term used for any lens with a focal length smaller than 40mm.

## Z

**Zoom Lens:** Lens with more than one focal length. Change focal length by adjusting a ring that moves lens elements. Also called a *variable focal length lens*.

# Index

**Front Cover Photos:**
Woman in water by Robert Farber,
lady in red by Tino Tedaldi,
two women by Andreas Heumann.

**Back Cover Photo:**
Tino Tedaldi